D1253382

Art and Faith

Art and Faith

A THEOLOGY OF MAKING

Makoto Fujimura

Foreword by

N. T. WRIGHT

Yale

UNIVERSITY PRESS

NEW HAVEN & LONDON

Published with assistance from the Louis Stern Memorial Fund.

Yale University Press books may be purchased in quantity for educational,
business, or promotional use. For information, please e-mail
sales.press@yale.edu (U.S. office) or sales@yaleup.co.uk (U.K. office).

Designed by Dustin Kilgore
Set in Adobe Garamond Pro and Avenir Next
Printed in the United States of America.

ISBN 978-0-300-25414-3 (alk. paper)
Library of Congress Control Number: 2020938043
A catalogue record for this book is available from the British Library.

This paper meets the requirements of
ANSI/NISO Z39.48-1992 (Permanence of Paper).

10 9 8 7

Contents

Foreword

Makoto Fujimura is one of those rare artists with the ability to explain what he does, why he does it, and how his vocation makes sense within his larger worldview. Since this worldview is explicitly and intricately Christian, this makes him doubly rare. As he says in this new and vibrant book, it has been fashionable among the Western art community to ignore or scorn faith of any sort, particularly faith in Jesus as Lord. I don't know whether this long-standing prejudice has come about because of young artists reacting against the earlier and powerful traditions of Christian painting, or because of the shallow and trivial versions of Christianity that many people in our day have encountered. But Mako's faith is anything but shallow or trivial. Like the amazingly delicate and complex materials with which he paints to such stunning effect, his faith commitment has been crafted and forged through good times and bad, emerging with the glow and multilayered texture we see in the paintings themselves. Since Mako honors me with occasional reference to my own work, I should happily disclose that I have been an admirer of his work, and then a friend, for several years. My two original Fujimura paintings

are among my most treasured possessions. I am therefore delighted to write briefly, not so much to commend this book—it will do that quite well for itself—but to celebrate it.

As readers will discover, the book itself is a work of art. Like Mako's paintings, its many layers of meaning are laid carefully on top of one another, with the individual parts crafted from materials prepared with patient skill. We have here a remarkable collage of biblical exegesis and interpretation, dialogue with artists and poets, reflection on the horrors of the modern world, musings on the Holy Land, deep visible roots in the Japanese traditions of art, and the sense of a personal journey undertaken in humility and hope, with weeping and worship never far from one another. In a book, of course, these necessarily appear one by one; but we quickly realize that each step in the argument colors, and gives vibrancy to, the others, and that we look *through* the whole collage at the great themes that emerge: the origin and meaning of all creativity in God the Maker himself; the new creation, already launched in Jesus and his resurrection; the way in which specific ancient Japanese techniques have enabled Mako to express in stunning visual effect his deep faith in the Jesus who leads his people through pain and suffering into the promised new world. The resultant picture is drawn together into a remarkable exposition, itself multilayered, of the scene in John chapters 11 and 12 where Jesus weeps at the tomb of Lazarus and engages the sisters, Mary and Martha, in rich, resonating dialogue, before Mary pours out her once-in-a-lifetime precious ointment upon Jesus himself.

This all adds up, as the subtitle suggests, to a "Theology of Making": the sequel to Mako's earlier work on "culture care," seen as his radical alternative to the destructive and futile "culture wars" in which so many Christians have been caught up in recent decades. In order to underpin that earlier work, Mako is here striking out on new pathways. These owe their life, both in form and in substance, to the truth of Jesus's resurrection—the event that is so much more than an isolated "miracle" and is

rather the beginning of the long-awaited new creation in which all Jesus's followers are called to share. This is where my own work has tried to point (from the jealous perspective of a scholar who sees that what the artist does is ultimately more important!) to the very thing that Mako is doing. If we believe that God raised Jesus from the dead, and that (as the New Testament insists) this has brought about the unexpected launch of new creation, of the "kingdom of God," on earth as in heaven, then our present vocations really do partake of that new creation, bringing fragments and flashes of new creation to birth in the midst of the still-darkened and sorrowing world. We are, to that extent, like the spies whom Moses sent into the land of Canaan, and who brought back fresh fruit from the promised land to the people still in the desert. That's what artists like Mako are doing: making sometimes dangerous forays into God's future, and returning to show an often disbelieving world—and, sadly, an often suspicious church—what that future is like.

One of the reasons for the suspicion is the mode of that showing. Some parts of the Western church have been so alarmed at rationalist attacks on the faith that they have attempted to mount rationalist counterarguments for belief. But the way forward, Mako insists, is not primarily intellectual, though it's clear on every page of this book that this particular artist can match the philosophers and theologians stride for stride. "God the Artist communicates to us first," he insists, "before God the lecturer"—one of many striking aphorisms that glint and glimmer through the multifaceted exposition. At this point I sense him joining forces with the Scottish thinker Iain McGilchrist, whose now famous book *The Master and His Emissary* explains how Western culture has been increasingly dominated by left-brain rationalism while in fact our brains are designed to work best with the right brain (the "Master") leading the way and the left brain (the "Emissary") working out the details. In other words, the way to human wholeness (and, for a Christian, the way to that human wholeness which the gospel offers) is found not through

the assembling of detailed facts and arguments in themselves—they will come in at the proper time—but through the imaginative leap to glimpse the larger world unveiled in the gospel.

Mako thus challenges the overrationalist reductions both of skepticism and of some types of Christian expression and apologetics. Nor is he the kind of romantic who supposes that artists have an automatic inside track on the mind of God, or that human imagination must always be right. "Imagination," he writes near the start of this book, "gives us the wings to create, but it is through Christ's tears and the invitation to the feast of God that we can be partakers of the New Creation." He therefore has warnings, not only for the undisciplined imagination of a kind of casual "whatever-comes" art or theology, but also for the kinds of Christianity that he refers to as "plumbing theology," theories of God's action in Christ that are designed simply to fix broken pipes rather than to ask what the pipes are there for in the first place. We are redeemed, he insists (for the avoidance of doubt, he insists strongly on a fully blown theology of redemption), not so that we can escape the world and go to "heaven," but so that in the present age as well as the age to come we ourselves can be junior "artists," apprenticed to the One True Artist, God himself. Pragmatism—in the art world, in the wider culture, and in a church life that looks for "success" only in human terms—is to be shunned. What counts is beauty. Beauty and mercy, in fact, are "the two paths into the sacred work of Making into the New Creation."

Mako has here adopted and modified—to my delight—a theme I have myself expounded. I have tended to speak of "Beauty and Justice": a celebration of the radiant glory of God's world, and a passion for the world to be put right at last. I have argued that only when the church is seen to be concerned with these two things will our message about Jesus—that he has come to rescue us from ugly chaos and the injustice of sin and death—make the sense it ought to make. Mako, picking this up, has undergirded my "justice" with "mercy." Against those who might

see justice and mercy as antithetical, he knows that God's longing to put the world right ("Justice") is in fact a crucial aspect of an even deeper characteristic, namely, the divine mercy.

This is the point at which we are introduced to the ancient Japanese tradition of *Kintsugi,* the art of taking broken porcelain—characteristically, items used in serving tea—and, by the golden material used for the repair, making of them something even more beautiful than before. (When Mako writes about gold, we sense the intimacy of the careful workman, as well as the insightful reader of scripture: "Even in Eden," he writes, "the gold was hidden. We have work to do.") This powerful image is then applied more widely, to human lives, to the life of the whole world. From broken teacups to broken lives and broken societies—mending is part of making, and making reflects and embodies God's redemptive purposes. Mako has known real pain and suffering in his own life, as well as being a close witness of the terror of 9/11 (he was in a subway car that had to reverse away from the disaster, and his family had to move from their apartment close to Ground Zero in the aftermath of the atrocity). He reflects on the pain of his devout grandfather who had been sent to inspect the ruin of Hiroshima in 1945. We sense here in Mako's writings what we recognize in the paintings: when this artist tells us that beauty can and does arise from ashes, he knows what he is talking about.

It is this vital strand of Mako's thought and work that has for some while focused on the tears of Jesus as he weeps at the tomb of Lazarus. These tears, we are reminded, were strictly speaking "unnecessary"; in human terms, they were a waste of time, since Jesus knew that he was about to raise his friend from death. But Mako insists on the artist's perspective: it was through Jesus's tears that the new life was to be born, just as it was through her tears that Mary Magdalene saw the risen Jesus. Here the vital theme of lament comes to the fore: the lament of Jesus, the lament of the Spirit within Jesus's followers as we look out on the world in its still-broken condition and work to produce genuine signs of

new creation within it, signs full of beauty and mercy; and, Mako would insist, the lament of God himself.

Here Mako draws deeply on various contemporary "makers": the poets Emily Dickinson and T. S. Eliot (whose *Four Quartets* Mako has carried about with him for years, as I have often done myself, and that in his case provided his sustenance during the dark days after 9/11), the artists Vincent van Gogh and Mark Rothko. (Towering over them, we come to realize, is the music of J. S. Bach.) Here he converges with the poetry of the Irishman Micheal O'Siadhail, whose book *The Five Quintets* takes Eliot's project to another dimension and in a very different mode, and who, like Mako, is constantly driving forward through the depths of sorrow into the joy of new creation. "New Creation," writes Mako, "fills in the cracks and fissures of our broken, splintered lives, and a golden light shines through, even if only for a moment, reminding us of the abundance of the world that God created, and that God is yet to create through us."

The point, all through, is that the new creation, which began when Jesus was himself raised from the dead, is the true life of God's coming new age, already visible precisely in the golden light that shines through—in art, in the Eucharist, in the entire mission of the church. That mission, Mako suggests, reverses the travel direction of the pilgrims "going up" to Jerusalem: we are told to go "down" into the places where the world is still dark, to "carry the tears of Christ" into the world. This is what Mako refers to as "Lazarus culture": the bringing of new creation to the places where the world is in pain. The scene in John 11 and 12 continues to yield powerful imagery: Mary's nard, poured out with lavish over-the-top generosity, "was the only earthly possession Jesus brought with him to the cross."

I am writing this in the middle of Lent. Mako's reflections offer a wise, rich seam of Lenten thought, always looking ahead to Easter but always prepared to wait in the darkness for the beauty and mercy to dawn

afresh. "There is no art," he writes, "if we are unwilling to wait for paint to dry"; and the same is true in the life of the Spirit. If we believe that what we do in the present in the power and Spirit of Jesus's resurrection really is part of God's glorious, abundant future, that constitutes a call to learn the discipline and virtue of patience.

This remarkable book both displays and encourages that virtue. It holds before us a vision and a vocation: the vision of God's new creation emerging through our sharing in the tears of Christ, and the vocation to be "makers," in whatever sphere, learning our craft from the Master himself. "When we make," writes Fujimura as the book gets under way, "we invoke the abundance of God's world into the reality of scarcity all about us." This is true Theology. It explains, too, why "making" in this sense is central, rather than peripheral, to presenting the gospel to an unready world. This book opens a life-giving vista on the beauty and mercy of God, and invites us to join in the feast.

N. T. WRIGHT

Art and Faith

I

The Sacred Art of Creating

When people ask me, "When did you first know that you were an artist?," I tell them I have been an artist ever since I can recall. My mother kept a painting I did when I was three years old. Many years later, after I established myself as an artist, I was astonished to see that it has exactly the same colors and movement that I am known for now. The journey of an artist begins at conception, and perhaps even way before.

Psalms 139:13–14 reminds us: "For you created my inmost being; / you knit me together in my mother's womb. / I praise you because I am fearfully and wonderfully made."[1] Perhaps in eternity's gaze I have been seen and created to be an artist in imitation of God, the Creator Artist. My identity is rooted in the origin of Creation, and in that loving gaze of the Creator, who sees in us a "greater love" before we are even aware: the creative impulse to shape the future.

My earliest memory is visual: I am one-and-a-half years old, just waking up from a nap, and from the window in my room I am watching my brother walk toward a preschool where we lived in Sweden (I was born in Boston but spent time in Sweden before moving to Japan for

grade school). I remember the color of the curtains and the Swedish flag waving in the crisp, morning sun. I am told that the painting I did later in Japan echoed those colors.

When I painted something as a child, I felt as if an electrical charge were going through me. That energy resounded over the surface of the paper. I thought everyone had this experience, but then I went to middle school (in New Jersey then). It was obvious that boys playing football or soccer had not had the same type of experiences that I had—noticing the beauty of the world around me or the visual patterns of a certain movement of the grass in the waning days of autumn while playing soccer. I did not want to be a misfit, so I kept such thoughts to myself. But these moments of creative discovery seemed sacred to me, even if I did not fully understand them.

In college, at Bucknell University in Lewisburg, Pennsylvania, I decided that these private thoughts about my visual experiences must be noted. But I still did not know exactly where these charges of energy came from. I knew that this was a gift, that it did not originate from within me. I felt William Blake expressed something very similar in his illuminated manuscripts. So I studied Blake, along with art and animal behavior. I graduated with a double major in art and animal behavior, and a minor in creative writing.

I would be introduced to Christianity later in my life. The journey started like a trickle of water falling from a faucet; drip by drip, through literature and art, through important relationships, and by creating and making, I felt I was honoring the source of beauty and poetry in the world. It took me a while to connect what I was experiencing to the message of Christianity. It's actually amazing that it took that long, now that I think about the core message of the Bible. This gap is one of my reasons for writing this book.

I understand now what I did not understand as a child: that every time I created and felt that charge, I was experiencing the Holy Spirit.

LITURGIES OF THE ARTIST'S WORK

I now consider what I do in the studio to be theological work as much as aesthetic work. I experience God, my Maker, in the studio. I am immersed in the art of creating, and I have come to understand this dimension of life as the most profound way of grasping human experience and the nature of our existence in the world. I call it the "Theology of Making," and I hope in this book to introduce its most important constellation of mysterious elements. It has become my point of reference for a lifetime of star-gazing into the infinite realities of beauty and the sacred—and then creating.

In my studios in Princeton, New Jersey, and Pasadena, California, in between pouring precious, pulverized minerals onto handmade paper to create the prismatic, refractive surfaces of my art, I rest in my quiet space, waiting for the paper surface to dry. As I wait, I write. Art making, to me, is a discipline of awareness, prayer, and praise. Imagination gives us wings to create, but it is through Christ's tears and the invitation to the feast of God that we can be partakers of the New Creation. I take note of the process by writing, and my thoughts in between, as I have done since my student days.

In the slow process of preparing the pigments and glue, which one must learn to do with the handmade paint that I use, I realized that I was practicing a devotional liturgy of sorts. I imagine my water-based paint to possess the tears of Christ. Even breaking the *sanzenbon nikawa* (animal-hide glue stick of "three thousands sticks"—as that is how the sticks were traditionally made in a vat) every morning seems sacred to me. I can tell the moisture level of the air by the sound and feel of the glue breaking. How much water to add, at what temperature, is determined by the type of painting I am working on and what I desire to accomplish. The somatic knowledge gained through years of making has become a way for

me to "understand" my own works. And through this act, I begin to feel deeply the compassion of God for my own existence, and by extension for the existence of others. My works, therefore, have a life of their own, and I am listening to the voice of the Creator through my creation. I am drawn into prayer as I work.

When I explain to strangers this sacred dimension of creating art, sometimes non-Christians have an easier time grasping it. Christians have many presuppositions about what Christianity is that are often based upon an analytical approach to understanding truth as a set of propositional beliefs, such that understanding and explaining take dominance over experiencing and intuiting. But that grounding is based less on a biblical, generative path than on the mechanistic, postindustrial thinking of utilitarian pragmatism.[2] Imagine trying to explain to a flying bird the aerodynamic forces at work when its wings move. Perhaps explaining it undermines the flight itself; perhaps the effort to understand it will not help the flying at all.

This is precisely why artists can open new doors of theological illumination in sharing what Christians call the Good News of the gospel to a world that has only a dim idea, if any, of what is so good about it. Simply by spreading our wings of art to take flight, we "prove" that gravity, or God, exists. When we make, we are taking that flight into the New. Artists, whether theists or atheists, know this truth deeply, and wrestle with this reality, inside as they create.

When we make, we invite the abundance of God's world into the reality of scarcity all about us. What endures will require risk and daily dying to ourselves. Certainly, the tears Christ shed at Bethany (John 11) and Jerusalem (Luke 13) mingle with our tears as we create: we live in a fallen world. Such intuitive overlaps are hard to explain rationally, and we tend to avoid the emotive, "feelings" side of experience; but as artists, we are trained to trust our intuition, to think through our feelings, and even to distrust our emotions at times to gain access to deeper integrated

4

realities. We artists dare not "understand" or overanalyze our creative acts, just as the bird does not need to understand the aerodynamics of flight.

All artists, in this sense, operate out of a faith in abundance and the experience of hope, despite the propensity of our egos to twist all that is good and make idols. If what we are created to do actually allows us to fly beyond the limited capacities of reason and observation, perhaps we will believe that there is abundance at the base of creation and that we can create out of that abundance without having to explain how we access it. We are free to take flight in the grace of its sustaining currents without knowing where the wind comes from.

Imagination, like art, has often been seen as suspect by some Christians who perceive the art world as an assault upon traditional values. These expectations of art are largely driven by fear that art will lead us away from "truth" into an anarchic freedom of expression. Yet after many decades of the church proclaiming "truth," we are no closer as a culture to truth and beauty now than we were a century ago. I have spent the past two decades developing a path toward what I call "culture care" away from the typical culture wars stance. In this book I outline a path toward culture care via what I see as flowing out from a biblical model of flourishing toward the New.

I often wonder whether the younger "None" generation (meaning they mark "None" when asked on forms whether they belong to any religious denomination or group or espouse a particular creed), for whom the old wineskin of how church is done may no longer seem relevant, is now limited to experiencing God authentically primarily through culture and nature, two areas that evangelicalism in the United States has abandoned in order to "evangelize" the world. Of course, God will be found in such a culture, but through distorted and limited lenses. The problem with our culture is that its river is tainted; if we try to find God through culture, we may be bowing down to idols and encountering twisted impulses rather than stepping closer to the true source of imagination

and creativity. Nature can be a door to the imagination, but it cannot, by definition, transcend the boundaries of the natural world. Technology and social media can be used creatively for life-giving storytelling, but they also can have life-taking results. So the "None" generation does its making through Instagram and iPhone technology; and the power of such a legitimate way of making has not been recognized by the church, other than when it says "let's 'use' these impulses to communicate the gospel and make disciples of these youth." But "using" is a utilitarian word, and I wish to affirm those who "make" rather than "use."

Some things, of course, are best conveyed in a three-point sermon. But we would lose a great deal if we heard the Good News delivered only as linear, propositional information, for the gospel is a song. I learned from theologian N. T. Wright to regard the very form of hymns and poetry as central to the gospel message. He mentioned Philippians 2:6–11 as a New Testament passage that is clearly poetic. "It isn't the case that first people sorted things out theologically and then turned them into poems," Wright observed, "but that from very early on some people—perhaps especially Paul—found themselves saying what needed to be said in the form of short poems."[3] What if the entire Bible is a work of art, rather than the dictates of predetermined "check boxes" for us to get on God's good side? What if we are to sing back in response to the voice of eternity echoing through our broken lives?

To be human is to be creative: "The characteristic common to God and man is apparently . . . the desire and the ability to make things," observed the writer Dorothy Sayers.[4]

To create anything seems to assume that there is a beginning: a blank canvas or page, an empty theater. The impulse toward Making seems embedded in us from "the beginning." Such an impulse imbeds our vision in actual earthly materials. So our journey to "know" God requires not just ideas and information, but actual making, to translate our ideas into real objects and physical movements.

The first chapter of Genesis states not only that God exists and created the universe, but also that there was such a time as "the beginning." This may come as a surprise to some who assume that time is eternal—that it had no beginning and will have no end. What is confusing is that God is eternal and is not in need of time; the notion of time seems to be a quality created for humanity's sake. So, from God's perspective, time may not be as significant as a clock seems to be from our perspective. Time is a self-imposed limitation in Creation that Jesus enters into.

Thus, the Genesis account is not just about the idea of Creation, but about the actual process of the Incarnation, of God's love to create the universe. I like to think, and many Hebraic scholars attest, that God the Creator sang the creation into being, that Creation is more about poetic utterances of love rather than about industrial efficiency, a mechanism for being, as many Western commentators may assume.

The Bible is full of Making activities. I have come to believe that unless we are making something, we cannot know the depth of God's being and God's grace permeating our lives and God's Creation. Because the God of the Bible is fundamentally and exclusively THE Creator, God cannot be known by talking about God, or by debating God's existence (even if we "win" the debate). God cannot be known by sitting in a classroom, or even in a church taking in information about God.

I am not against these pragmatic activities, but God moves in our hearts to be experienced and then makes us all to be artists of the Kingdom. The act of Making can lead us to coming to know THE Creator personally, even though I realize that the "opening of the eye" experience is not a guarantee of that personal knowledge. All that is to be known about God comes first through God's desire to be known and revealed. The Word of God, such a revelation, is the central means of tapping into this creativity of God. The Word of God is active, and alive. God the Artist communicates to us first, before God the lecturer.

The Bible affirms this way of God's revelation among humankind.

Among the extended passages in the book of Exodus about creative work is one describing the craftsmen of the Ark of the Covenant, Bezalel and Oholiab, who are said to have been "filled . . . with the Spirit of God, with wisdom, with understanding, with knowledge and with all kinds of skills" (Exodus 35:31). It is the Spirit of God, the God who creates, who fills us in order to create (and as the later passages indicate, with "the ability to teach others" [35:34]). Bezalel and Oholiab are the first examples in the Bible of human beings filled with the Holy Spirit.

To God, and to the writers of Exodus, these artisans were so important that their names are recorded. These craftsmen were probably trained in Egypt, perhaps in slavery; thus God used "pagan" training to prepare them for a higher purpose.[5] The skills that these craft folks learned in Egypt created the idol of the golden calf under Aaron's misguided instruction (Exodus 32). Now, they were to follow God's detailed instructions to build the Ark, to sanctify their imaginations toward the sacred.

I have experienced this myself, as I was trained in a lineage program in Tokyo, learning the ancient craft of *Nihonga*, which I apply to contemporary expression. Inspiration and training have what theologians call "prevenient grace" (bestowed at God's initiative, not on the basis of human activity) operating throughout, and God is a God of all cultures in that sense. We may or may not be conscious of such inspiration to create, and if we are, we may not understand the origin of that experience. But the Bible makes clear that God commissions all people to create for the New.

It has been said that "a work of art is something new in the world that changes the world to allow itself to exist."[6] Had Bezalel and Oholiab not been filled with the Spirit to create out of the knowledge of craft that they had learned in Egypt, it would have been impossible for God's chosen people to worship, and to have a visual identity that gives them a unique place in the world. In Bezalel and Oholiab's obedience to the strict details of the design of the tabernacle of Moses given by God, God

worked through them to make worship a reality for the Jewish exiles. It's also important to note that these intricate designs for a structure to literally "house" God's laws were given at the same time as the Decalogue, which indicates the high value God places on design and Making.

The Bible depicts God as all-sufficient, all-powerful, all-knowing. *If God is all-sufficient, or self-sufficient, then God does not need anything.* God does not need us. God has never been lonely; Genesis makes it clear that before Creation, the triune God existed already in community. God is also self-existent, meaning that God does not require anything other than God's own existence for completeness. The Hebrew word meaning "the beginning" (*reisyt*) suggests that even fruitfulness already was embedded. But somehow, God created in order to mark God's own signature for our journey. What this marker does is to enfold a narrative of what the literary critic Frank Kermode calls "the sense of an ending."[7]

God's design in Eden, even before the Fall, was to sing Creation into being and invite God's creatures to sing with God, to co-create into the Creation. A narrative of our own creation is embedded in Creation. The Christian narrative is all about the New, all about the beginning. And part of that ushering in of the New is God's marker in us, called imagination, which makes us unique in the animal kingdom. We can create into Creation something unique and particular. Thus, in Genesis 2, we see Adam's first act of creativity: naming the animals.

THE SACRED IMPULSE OF CREATIVITY IS REDEMPTIVE

My friend Lisa Sharon Harper observes in her exegesis of Genesis: "It's important to note that God does not obliterate the darkness; rather, God names it and limits it—puts boundaries on it. The boundary is the light."[8]

Some years ago, I created paintings for an edition of the four New Testament Gospels.[9] As I painted the cover, *Charis Kairos—The Tears of Christ,* the signature piece for the project, I began by creating a dark, nearly black gesso. (Gesso is put on the canvas to "size" the surface so other materials can be placed on top.) This journey using black gesso began when I did a special project to honor the legacy of the Parisian modernist master Georges Rouault in 2009 at Dillon Gallery in New York City and continued when I worked with the painter Bruce Herman and composer Chris Theofanidis on a project we called QU4RTETS based on T. S. Eliot's *Four Quartets.*

In the paintings for the Dillon Gallery show I wanted to honor Rouault by using a dark canvas as he had done, painting in the bleakness of postwar Paris. Rouault depicted darkness head-on and yet brought in the aesthetics of his earlier apprenticeship in a stained glass studio. He literally placed colors as light emanating out of darkness.

Later, in the QU4RTETS collaboration, I worked with my assistant Lindsey Kolk to develop a gradual, subtle movement of dark gessoes across four canvases. Miraculously, what ended up being birthed were canvases on which the darkest gesso looks the brightest, and the lightest (gray) gesso looks the darkest.

In both cases, I began with the darkness and used pulverized minerals to create prismatic colors (akin to stained glass windows) as "boundaries" of light. In art, we do not "obliterate the darkness"; art is an attempt to define the boundaries of the darkness.

Lisa's book *The Very Good Gospel* moves further into an exquisite exegesis of Genesis 1 with a focus on justice and mercy. She contextualizes Genesis passages as most likely written during the postexilic journey of the Israelites out of Babylonian captivity. Therefore, these passages reflect a theological structure that speaks against forces of darkness that oppress and enslave. The three key Hebrew words *tselem, dmuwth,* and *radah* bring a fresh voice of liberation from enslavement and oppres-

sion, and I want to push these concepts further into the Theology of Making.

Both *tselem* and *dmuwth* suggest a path that God intentionally took to "re-present" to us, and Lisa notes the connection between *tselem* and the Greek word *icon*. Instead of a brutal dictator, we have a Creator God who seeks full thriving, justice, and mercy. Just as Caesar's portrait is stamped on a coin as an icon to represent earthly power, God places God's "face" upon our hearts. God's presence is real, even in the midst of oppression and darkness. God is the light that shines and places limits on evil and injustice on the earth.

What if, in response to Lisa's point, we began to paint (or write songs, plays, and poems) into the darkness with such a light? What if we began to live our lives generatively facing our darkness? What if we all began to trust our intuition in the Holy Spirit's whispers, remove our masks of self-defense, and create into our true identities hidden in Christ beyond the darkness? What if our lives are artworks re-presented back to the Creator?

The word "dominion" (Hebrew *radah*) has been misused to mean "practicing domination over" or ravaging creation for industrial purposes. But, as Lisa notes and theologian Ellen Davis affirms, a more accurate understanding of *radah* is "loving stewardship." Proper stewardship is based on love of the land and its peoples. Proper stewardship is part of our poetic responsibility to Creation. I connect this Hebrew word *radah* to the Greek word *poietes* (maker), as I detail in the following chapters. One aspect of our stewardship is to become poets of Creation, to sing alongside the Creator over Creation. In other words, in such a modern translation, suited for a time of high hopes in the Industrial Revolution, a word such as *radah* is tainted with the notion of industrial utility.[10] "Loving stewardship" might have meant a time in which nature was a "wilderness" to be tamed by industrial domination, as in "practicing domination over," but *radah* is a Making word, rather than a forceful domination.

God's Word is the Light; Jesus told us that he is the Light. If light places boundaries over the darkness, then our art needs to do the same. God is not just restoring us to Eden; God is creating through us a garden, an abundant city of God's Kingdom. What we build, design, and depict on this side of eternity matters, because in some mysterious way, those creations will become part of the future city of God. Even in seeking justice and fighting against injustices of the world, if we do not depict future hopes, as Martin Luther King, Jr., did in his "I Have a Dream" speech, we will be constantly defined by the opposition or the power of oppression. Art can be a means to liberate us from such oppression by depicting the world through beauty and truth, to point to the New.

For *The Four Holy Gospels* project, to narrow my focus on this rather ambitious work, I chose to use the "pinhole" of John 11:35, the shortest verse in the Bible: "Jesus wept." If God is self-sufficient, and Jesus was God's only Son, then Jesus did not need us, nor did he need to weep over us. Jesus's love extends beyond a utilitarian need to survive or our pragmatic need for a savior. Jesus's tears are gratuitous, extravagant, and costly. My art imitates this, through the use of expensive minerals, gold, and platinum and a reliance on a slow process that fights against efficiency. Experiencing God through a creative process may fight against our assumption that such a process can be done by taking in data and processing it efficiently.

MAKING IS A FORM OF KNOWING

Consider a journey toward "making as knowing." The word "making" (related to the Greek words *poiema* and *poietes*) takes a central focus on entering theological terrains. I am an artist first, making sense of theological knowledge from the creative intuition I have nurtured and refined over the years. From the vantage point of an artist, the God of the

Bible is a Maker/Creator first and ultimately. God may be called not just the first Artist; to me, God is the primal reality of Making, the ultimate "definition" of the Artist. In other words, God is not just the "first order" from which all creativity flows; God is the Maker of all things, preexisting to all forms of knowledge, including the very concept of the "first order."

Thus, when I speak of God as Artist, I am speaking of God not just as the only true Creator—the ultimate Maker, as passages from Genesis describe—but also as the *originator of origins,* the creator of any notion of a Maker. The holiness of God, in this journey, is "otherness" and is set apart from our creativity and imagination. In many ways, we must distinguish between God's creative act and human creativity (what theologians call "Creator-creature distinctions");[11] but at the same time, the Theology of Making assumes that human creativity echoes God's character and is made in God's image in some way. So when I state "God is THE ultimate Artist," I am not trying to define the original Creator by human terms. I am stating a presupposition up front that the very definition of "art" may need to be redefined by biblical and Godly terms, and that God is the only true Artist that exists.

The Greek word *poieo* (to make, to do) and its related words *poiema* (that which has been made or done) and *poietes* (a maker or doer) appear more than thirty-two hundred times in the Septuagint (the Greek version of the Hebrew scriptures) and more than eighty times in the New Testament. Note the significance of these words, which have to do with making. Some translators translate *poieo* as "to do" (as in "doers of the Word" in James 1), which reduces its generative possibilities and focuses on a rather industrial sense of the word. Part of the Theology of Making is to bring full color to these words, which are often interpreted in a narrower sense. While it is not wrong to translate *poieo* as "to do" or *poietes* as "doer," the emphasis on the Maker will necessitate revisiting the passages that give such words their full significance.[12] Since the word "making" has been taken over by our industrial past, when we discuss the

Theology of Making, a presupposition is at work that the word "make" should be used to express "useful" or "efficient."[13]

In this book, I draw more from the poetic use of the word—again, the generative association. Making is the fundamental reality of *Homo faber* (man the maker, not just *Homo sapiens*) and what uniquely defines our role in Creation. We are *Imago Dei,* created to be creative, and we are by nature creative makers.

I interpret Ephesians 2:10 as "We are God's masterpiece [*poiema*]" rather than using the common translation "workmanship" or "handiwork." God sees us already perfect in Christ, and in Christ we are a "new creation" (2 Corinthians 5:17). Christ has already done for us the necessary work of perfecting us, even before we are aware of that as God's grace in our lives. The passage that follows this word *poiema* is also important: "created in Christ Jesus to do good works [*ergois agathois*]." The Greek word *ergon* means "hard work," but I interpret it to mean "refined works." We are created by and for and through grace, and yet our work here is hard work through many strenuous journeys of "carrying our own cross."[14]

This interpretation of Ephesians 2:10 is reflected in the beautiful writing of Norman Maclean in *A River Runs Through It:* "My father was very sure about certain matters pertaining to the universe. To him all good things—trout as well as eternal salvation—come by grace and grace comes by art and art does not come easy."[15]

"Art does not come easy": this sacred, God-given impulse, *poieo/poiema/poietes,* both "doing" and "becoming a poem."[16] It is hard work to live into this generative love, and it is what we are made for: to paint light into darkness, to sing in co-creation, to take flight in abundance. A beautiful native brown trout, or the eternal presence of the Maker in the rushing waters brimming with life, comes by grace, and such is the artistry of the Artist who creates for, in, and through us.

2

The Divine Nature of Creativity

To be effective messengers of hope we must trust our inner voice, our intuition that speaks into the vast wastelands of our time. In this way we can train our imagination to see beyond tribal norms so we can take in the vista of the wider pastures of culture. I often describe artists as "border-stalkers" in our cultural ecosystem.[1] They cross tribal norms to see the whole, to navigate in between the walls erected to protect the tribes.[2]

Therefore, part of experiencing the presence of God in our lives is appreciating the importance of our creative intuition and trusting that the Spirit is already at work there, often working in between established zones of culture. Our creative intuition, fused with the work of the Spirit of God, can become the deepest seat of knowledge, from which our making can flow.

But of course, the first wall of resistance that the creative process runs up against is our contemporary Western cultural concept of "usefulness"—what the French philosopher Jacques Ellul warned against in the mid-twentieth century as the dominance of "technique."[3]

THE DANGERS OF "USEFULNESS"

Artists and poets are the first to intuit, before anyone else, the encroaching darkness of dehumanizing forces. Emily Dickinson wrote in the early hours of the morning on her small cherry wood desk in her family's homestead in Amherst, Massachusetts, looking over a main street that would have many local young men returning from war in coffins. She called this "The Morning after Death" and the entire business of funerals the "solemnest of industries."

"Solemnest of industries" refers to practical matters, but metaphorically, Dickinson also taps into the question of purposefulness. She relies on the mechanics of the Industrial Revolution for her description of despair. Her words, in that sense, are consistent with so many voices of the nineteenth century (for example, William Blake, Thomas Hardy, and Walt Whitman) that saw the language of "usefulness" and industry dehumanizing our culture to capture what she termed, in her turns of ironic phrases in the same poem, "The Sweeping up the Heart." Even her role to clean the house reminds her of the sinister shadows of utilitarian mechanisms that are taking over her world. All things, it seems to her, connect deeply with death; and our efforts, whether they be wars, business, or religion, seem not to capture the essence of our true being but instead force definitions and impose categories upon us.

What do we remember and speak of on our deathbeds? We do not boast of our résumés, or how much money we have in our bank accounts, or our educational degrees or fame. Most likely, we speak of the intangible experience of life, of the most precious treasures that we hold dear, of our loved ones. As Dickinson refers to here, it is all about love. That "Sweeping up the Heart" is forced upon us by a loved one's passing, or the entire town mourning; and in that "solemnest of industries" we endeavor to move on in pragmatism and in efficiency, as if we are to

16

efficiently cover up the wounds, recover the shattered limbs, and bury the dead to move on.

Emily Dickinson used lots of dashes and hyphens, despite editors of her time wanting her to remove them because they found them unnecessary for the purposes of a poem. But as I have argued elsewhere, these "unnecessary" elements were her main identity.[4] If that is true, then what may be gratuitous, the "extra" of our world, may turn out to be the most essential. So Dickinson's dashes speak of reality far beyond our "use."

Artists are notorious for doing work that the world initially rejects but that later—sometimes centuries later—the world embraces as hidden treasure. The poems of Emily Dickinson, the paintings of Vincent van Gogh, the music of Johann Sebastian Bach, all were "discovered" later and now are essential to our culture. Could it be that what is deemed marginal, what is "useless" in our terms, is most essential for God and is the bedrock, the essence, of our culture? Could it be that our affinity for the utilitarian pragmatism of the Industrial Revolution created a blind spot in culture that not only overlooks great art, but if purity of expression is compromised could also lead us to reject the essence of the gospel? Could it be, if I may extend this thought to the extreme, that we have missed the essence of the gospel message by focusing merely on an industrial, commoditized way to convey the information of the gospel, or even to "sell" the Good News in the most efficient manner prescribed by our entrepreneurial or industrial mindset?

GOD CREATES OUT OF LOVE, NOT NECESSITY

A concerned friend once advised me never to share in a church setting what I had just told him—"God does not need us to fulfill God's need: God does not need us."

There's a type of need to justify the existence of the institution of

the church (or any nonprofit organization) to be "useful to society," and thereby useful to God. While the impetus is noble, we must start from the correct biblical understanding of God's self-sufficiency. God does not need any of our institutions to exist, period; but God's exuberant love invites us, broken vessels of God's choosing, to co-create into the New Creation through Jesus.

God is all-sufficient, self-sufficient, and does not need Creation either. Creation, including humanity, is a superfluous act of generosity in God's love. My friend's comment helped me see how the Christian church to this day has been undermined by the utilitarian mindset of the Industrial Revolution. We see our existence and value only in terms of "fixing the world." The gospel of a Creator who acts out of love, not necessity, liberates us from this bondage.

The Westminster Confession of Faith states that "God has all life, glory, goodness, blessedness, in and of Himself; and is alone in and unto Himself all-sufficient, not standing in need of any creatures which He has made, nor deriving any glory from them, but only manifesting His own glory in, by, unto, and upon them" (2.2).

God exists outside of time and space, not needing to create this world. Some have called this the aseity of God, from the Latin *a* ("from") and *se* ("self"). So why did God create? Our view of the creative process and the role of art hinges on how we answer this question. *God created out of love.* God created because it is in God's nature to make and create. The Theology of Making assumes that God created out of abundance and exuberance, and the universe (and we) exist because God loves to create. Some will misunderstand what I just stated and ask, "But isn't there a purpose behind creation, or purpose in the cosmos?" Yes, but this purposefulness goes far deeper than in the industrial sense.

Ever since the Industrial Revolution, how we view the world, how we educate, and how we value ourselves have been all about purposeful efficiency. But such bottom-line utilitarian pragmatism has caused a split

in how we view creativity and making. To what purpose, we ask, are we making? If the answer to that question is "we make to be useful," then we will value only what is most efficient, what is practical and industrial. The thesis that undergirds the entire culture care project, and the Theology of Making, is an antidote to such utilitarian pragmatism: the essence of humanity under God is not just utility and practical applications; the essence of humanity may be in what we deem to be "use-less" (to use the hyphen in a Dickinsonian way) but essential.[5] The deepest realm of knowledge is in Making, and, conversely, Making is the deepest integrated realm of knowing.

THE ORIGIN OF THE CREATIVE PROCESS

The theologian Karl Barth writes of art:

> Being borne and born by pain is particularly the lot of art because this is by nature an expression, a special action which introduces special works, an action whose alien character as play cannot be concealed or diminished in the midst of the seriousness of the present. The artist's work is homeless in the deepest sense even though it is also real work alongside scholarship and church and state. Art does not come within the sphere of our work as creatures or our work as sinners saved by grace. As pure play it relates to redemption. Hence it is at root a non practical and lonely action. It belongs to the empty sphere of the uncontrollable future in the present.[6]

Art, considered "an action whose alien character as play" of "the seriousness of the present," leads to Barth's statement that "the artist's work is homeless." Such is the predicament of Emily Dickinson and

thousands of other artists today. I argue in this book that the "seriousness of the present" of artistic practice reveals God's work in Creation, a "work as sinners saved by grace" and therefore essential for an understanding of God's truth. It is through such grace that the extravagance of artistic ventures, a "pure play," can mimic the Creation of the Creator God. Art does seem "non practical" and certainly is a "lonely action" in the context of an "uncontrollable future." But these negatives are not worth comparing with the glory that will be revealed in our creative lives (Romans 8).

The Bible begins with Creation and ends with New Creation. Everywhere in between, Creator God (the grand Artist) beckons the broken, but creative, creatures (the little-'a' artists) to create shalom/peace in the face of our "Ground Zero" reality all around us. God sent God's Son, Jesus, to be the reconciler and redeemer—to set the world right, and to exhibit God's love in the world. Jesus, God incarnate, spoke in parables and exhibited artistic qualities that inspire me as an artist. We are created to be creative, though as fallen creatures we are bound to twist these good impulses to boost our egos and cover up our insecurities, or—worse yet—create weapons of mass destruction.

The Bible is a "creative book" in that creativity plays a central role in advancing God's plan, but it is not to be interpreted "creatively"; we are not to read the Bible to make it fit our own desires. We cannot impose our own ideologies and presumptions. In order to fully understand, we must first learn to "stand under" the book.[7] We let the Bible examine us, to probe deeply into our hearts and our lives. As we do, though, our Creator gives us a mandate, despite our brokenness: to create in, through, and for love. This growth journey is the "slow art" journey into the Bible.

The significance of this approach reveals the Creator who resides outside of time and space, thereby resisting the reductivism of modern assumptions. Philosopher Esther Meek speaks of our need for "epistemological therapy," meaning that we need to examine the roots of what we assume to be "knowledge."[8] (Epistemology is the philosophical study

of knowledge.) I spend a considerable amount of time describing and explaining this journey of knowledge in the later chapters. Why? The Theology of Making challenges the common, truncated "understanding" of what Christians call the gospel and recovers the fullness and richness of the biblical narrative from modern, reductivist assumptions. This theological journey of recovery into the abundance of God, the fullness of redemptive and New Creation theology, not only enlivens theology, or how the gospel is preached; it also affects other disciplines.

Seeing the redemptive act of God, the ultimate act of Christ's sacrifice on the cross of Calvary, through the lens of Creation and the Holy Spirit's work awakens in us the potential of the New Creation. My focus is to see this entire gospel narrative be affirmed. Further, we are invited as God's co-heirs to co-create into that future (Romans 8:16). Much has been made in the pulpits of churches of the "spirit of the world" as a force of willful rebellion against God's will and Creation standing against culture. Imagination and art have been seen as suspect, as human arts have been associated with the "spirit of the world" (a common translation of the Greek word *stoicheion*) or "flesh" (from the Greek *sarx*) rather than with the Holy Spirit. For me, the spiritual battles are certainly real, and our "flesh" is at work in our lives to draw us away from our true selves, from our authentic selves that God has intended us to be. A respect for our calling to a sanctified imagination can help us understand the effect of idol making connected with the "flesh." When we treat human institutions or nature as God, or when we rely alone on human ego, or political power, to determine our future, we are creating idols that attempt to replace God at the center of our being and our hearts.

The sacred role of creativity and a theology that is cast toward, and through, the New Creation in us can provide a path toward restoring imagination, as based in the sanctified realm of the Holy Spirit and as made possible by Christ's sacrifice and the Holy Spirit's gift as an invitation to co-create into the future of God.

By "co-creating into the future of God," I do not mean that some-how we have the equal weight of power or knowledge to co-create with God. God is the greatest, and perhaps the only, power there is, so what does it mean to co-create? It means to be invited to a dance, invited by God's grace to be on the stage, to step into a journey of New Creation that we do not yet fully understand. Co-creating is accepting the Cre-ator's invitation to a feast and supping on what is provided abundantly to us. For mysterious reasons, God chooses to depend on fallen creatures to steward God's gifts, as poignantly signaled by the incarnate child in the manger who, though he was God, needed human help to survive. Through this weakness and vulnerability, God incarnates into the world that is full of danger and violence.

Many will assume that the word "redemption" includes this invita-tion to co-create into the future. But often, redemption is understood as our return to a perfected state, rather than the New. Much theology has been written on redemptive purposes for salvation, purposeful goals, but when it comes to this New Creation that the various writers of the Bible point to, we have very little in the way of a theologically developed thesis. I have found a harbor in Bishop N. T. Wright's exquisite theologi-cal writings, particularly the chapter titled "New Creation" in his book *Paul: A Biography* from 2018, as well as his book *Surprised by Hope* from 2007. Throughout this book, I refer to Wright's writings and those of other theologians who have helped me to journey into this notion of the New.

The typical theological path is Creation–Fall–Redemption–Restora-tion. "Restoration" can assume the path back to Eden. Restoring a bro-ken world is a noble goal, and yet biblical promises go further than even that ideal. One might say that our "ideal" needs to be paradigmatically shifted to the New, and that our notion of the perfected state pales in comparison to the actual reality of the resurrection. A theology toward the New Creation modifies the sequence to Creation–Fall–Redemption–

New Creation. Some have used the word "consummation" for this eternal promise, but the New Creation is a better phrase to signify the generative, expansive promise of the New. Of course, the redemptive message is the central tenet of the Christian gospel; Jesus came to liberate us from our "bondage to decay" (Romans 8:21). Yet, in my journey of creativity I have learned that darkness also sheds light on the depth of grace that we can journey into. (This idea is developed further in Chapter 4.) It is through the lens of Creation that we can understand the Fall. The Holy Spirit can transform us into people who abound in the "fruit of the Spirit" (Galatians 5:22). Such fruit, if it is truly the Spirit's operation, will be manifested in culture as well as in individuals. Thus, culture care is the vision to manifest the "Spirit-filled life" into the heart of culture. Through the lens of the New Creation, we can fully understand what that manifestation will look like and come to know deeply the redemptive purposes of God.

Saint Paul writes in his epistle to the Galatians: "But the fruit of the Spirit is love, joy, peace, forbearance, kindness, goodness, faithfulness, gentleness and self-control" (Galatians 5:22–23). What I offer as culture care is a consideration of the work of the Spirit in culture. In other words, we ask not just how you or I may be doing as a follower of Christ; we also ask audaciously, "How is our culture doing?" When we ask this, we realize that our individualistic efforts to be "filled with the Spirit," through all our church and parachurch programs, have not resulted in a culture that is full of the fruit of the Spirit. Instead, our culture is filled with divisiveness, depression, angst, impatience, battles to be won at all costs, selfishness, pettiness, unfaithfulness, and anger. In other words, we have created an opposite extreme of what the Bible teaches us to create, as part of the fruit of the Spirit in the world. Thus this approach toward an integrated knowledge of Making offers an alternative way to create culture in our midst, as beauty made through self-sacrifice can lead to the incarnation of what God's love can offer to our world.

The path of creativity gives wings. The essential question is not whether we are religious, but whether we are making something. When we stop making, we become enslaved to market culture as mere consumers. But in order to understand the path toward Making into the New, we must first deal with the philosophical assumptions of our days and the modern tendency to base our understanding on knowledge we acquire through rational, propositional information. Art is another way of knowing the world, and artists are being pushed to the margins because of their intuitive knowledge.

Artists know instinctively that no discussion is purely an exchange of information. The moment we start discussing an idea, we use words, and words involve interpretation, metaphors, and expression that stir the imagination. Even the distinction of "right brain" and "left brain" starts to break down as an antiquated notion of how the complex brain functions. We paint using words, employing artistry and metaphors to communicate. We must use integrated language toward knowing if we are to capture the flow of the rational to the intuitive.

Our culture has long been driven by information; many people are inclined to believe only what can be verified and rationally ascertained. More recently, we have been surprised by our vulnerability to "fake news" and false information delivered through the "trusted" medium of the internet; we seem to "verify" by relying on the "rationality" of technology, but indeed, we are easily manipulated because we trust in the form, rather than the content. We have not done a good job of articulating the difficulties and gaps present in communication, or how to incarnate ideas into reality. We have assumed that informational "recipes" are the sole basis for knowing truth. It is time for us all to taste the actual fruit of the act of making. The act of making is the antidote to our current malaise, to the collapse of communication that has resulted, in the words of David Brooks, in "a rapid, dirty river of information coursing through us all day," resulting in the need for "an internet cleanse."[9]

In order to be effective messengers of hope, we must begin by trusting our inner voice, an inner intuition that speaks into the vast wastelands of our time. This process requires training our imagination to see beyond tribal norms, to see the vista of the wider pastures of culture. Therefore, it is part of our theological journey to see the importance of our creative intuition and trust that the Spirit is already at work there. Our creative intuition, fused with the work of the Spirit of God, can become the deepest seat of knowledge, out of which a theology of the New Creation can flow.

3

Beauty, Mercy,
and the New Creation

Beauty and mercy are two paths into the sacred work of Making into the New Creation.[1] Neither one of these elements is essential for survival in a Darwinian sense, but both can be seen as crucial for a gift economy—which is the underlying economy of the gospel and essential to the thriving of art—to work.[2] From a Darwinian viewpoint, beauty and mercy are not only unnecessary, but even dangerous. Many have argued that the reason we have an innate drive toward beauty is to attract and be attracted to mates. Under such a statement is the utility mindset, a presupposition that because the world must be mechanistically driven toward the survival of the fittest, beauty (and mercy) must subject its function to fit that presupposition. This model trains us to make decisions based on what will help us survive in an environment of limited resources. When that is the framework for the choices we make, altruism does not make sense; it seems like wasting time to create beauty or to stop and pay attention to the "least of these" in an act of mercy.

I have argued that beauty is connected to sacrifice, more than the superficial "look" of how we may seem to the outside world.[3] To give your

life away, as Jesus has done, is truly the opposite of Darwinian survival. (There is a counterargument to even this, that altruism is good for the survival of the whole, which is steeped in the same presupposition.)

Beauty and mercy invoke the New Creation precisely because they may be unnecessary for survival in the Old Creation. A theology toward New Creation makes an audacious argument that mercy and the creation of beauty are the foundational essence for how we, fallen human beings, can participate in the sacred creation of the New. Without beauty and mercy, the gospel will not change the world. They are two "upside down" paths to imagining the Kingdom of God, and it is as we travel along these avenues of imagination that we are transfigured into what God has intended for us.

JESUS'S VISION OF ABUNDANCE

I stood above the hills of Galilee looking over the oasis that the Sea of Galilee creates. The hills were bursting with green, as the seasonal rain had passed through the region in February. Soon, the migration of more than five hundred million birds from Africa would begin. Above these hills where Jesus gave his Sermon on the Mount, millions of storks would soon pass overhead (if they were not shot down in Syria, where military snipers use them for target practice).

When Jesus told the multitudes listening to that sermon to "consider the lilies of the field" (Matthew 6:28), he was speaking of the abundance of God's Creation in one of the few oases of Israel. He intentionally inaugurated his ministry there, selecting his disciples (mostly fishermen) from that region. Thus, in both the words and the setting of the Sermon on the Mount, Jesus invoked Creation and invited the New Creation. He was also bringing out the narrative of the creation of the Temple in depicting a new community, later called the Christian church, as part of

the New Creation. But the staging took place in Galilee, with literally millions of birds flying over in the cooler seasons of the year. The Bible is a story that moves from Creation to New Creation. The redemptive journey of Jesus moves toward Calvary; then, in due time, broken earth and the death of Christ become broken shards restored and re-created into the New.

In a sense, all art points to the voice of abundance speaking into our parched souls in the desert of our industrial wilderness. The "Tender Pioneer" (Emily Dickinson's words for Jesus) brings us awareness of what is already present in our immediate, generative experiences, but also guides us toward the New.

FIXING VERSUS CREATING

In such a voice of abundance spoken directly into our daily survival game, we need to locate ourselves in a context of making, rather than stopping at "fixing." In my studio, I make art. A theology toward the New amplifies how this human act is connected to the divine presence. Simply put, when we make, God "shows up." Therefore, before I begin a discourse on what God has done to make even our broken shards of life invaluable essences of the New Creation, let me first describe the creative process that an artist knows well, and how God the Artist reveals a vision beyond the "fixing" of our lives, a type of theology I call "plumbing theology."

In hearing many sermons across many denominations, I have found that we tend to depict the gospel as a message of "God fixes things"— which is what I mean by plumbing theology. As I have noted, the consummation of God's plan as it unfolds in the Bible is not a utilitarian restoration but an imaginative New Creation. When we read the entire arc of the Good News, we realize that the focus of God is on creating:

first the Genesis Creation, then the tabernacle and the First and Second Temples; and through Christ's Redemption and the Holy Spirit's filling; the New Temple of Christ's Bride, the church; and then the New Creation. The redemptive narrative does not make sense unless we believe that God created the world, which was abundant and thriving, and that despite what happened in Eden God takes us beyond Eden. Plumbing theology answers what God did to "fix" the problem of the Fall (through Christ's salvific work on the cross), but it does not address why we need the plumbing fixed to begin with.

Churches that are active in social causes, for instance, encourage their congregations toward political and other activism, toward noble causes. On the other hand, evangelical churches are heavy with marriage seminars, programs to share the Good News, and other ways to fulfill both the Great Commission and God's Creation mandate (that God created the world for us to steward)—again, all good causes. But often the emphasis is on how God, through the Spirit, restores us to be whole; and how, by our activism or by being filled with the Spirit, we can present a polished, respectable life. It's as if to say we are "fixed" by the gospel, and we can now live out our identity as a New Creation in Christ. But we do not know what purpose and what world we are being prepared for. Again, it's as if we are provided with tools to fix the pipes of injustice and righteousness, but we have no word on why the pipes are there in the first place.

Thus, when we go to church, it can seem like we are being given a new tool to fix the broken pipes every week. We are to take that tool home and use it diligently to fix the pipes of the broken world, and the next week, we go back to receive a new tool and instructions on how to use it. Meanwhile, we are also to invite our neighbors to join us in fixing their pipes, and if we can entice them, to go to church with us the next week so that they can help spread the word on these tools of fixing the world. But meanwhile, there is no conversation about why we are fixing

the pipes and what the pipes are for. What, we may ask as we are using our tools, is going through these pipes?

What are the pipes for?

Artists already live in the abundance of God. They see beyond the pipes. They hear the "music of the spheres" and desire to respond; they see a vista beyond the world of gray utility; they desire to paint in color; they dance to a tune of the Maker who leads us beyond restoration into the New World to come.

God does not just mend, repair, and restore; God renews and generates, transcending our expectations of even what we desire, beyond what we dare to ask or imagine. In a stunning way, Bishop Wright expands on this theologically:

> What you do in the Lord is not in vain. You are not
> oiling the wheels of a machine that's about to roll over a
> cliff. You are not restoring a great painting that's shortly
> going to be thrown on the fire. You are not planting
> roses in a garden that's about to be dug up for a building
> site. You are—strange though it may seem, almost as
> hard to believe as the resurrection itself—accomplishing
> something that will become in due course part of God's
> new world.[4]

Preaching and teaching therefore should address the New Creation and not only offer the "fix" required after the Fall. Again, I am not saying that the "fixing" message is to be avoided, but I do think it is incomplete. Rarely do I hear preachers address the reason why the pipes exist in the first place. I see three biblical reasons for the existence of the pipes:

- Through the pipes flows the Holy Spirit to empower us, the broken people and fallen Creation.

- Through the pipes flows the blood of Christ to restore us and rejuvenate the earth.
- Through the pipes flows the wine of New Creation to invite us into the feast of the New. But the wine of the feast will flow backwards from the New Creation to our reality.

All art, music, and poetry, by intention or not, invokes the New. Even a non-Christian creating must have some sense of hope or it will not be possible to create into a future audience that will have a future encounter with that work of art. These three aspects of New Creation are simultaneously working together to empower, to restore, and to create into the New. What if we began to create, and live, into the New Creation to come?

EMPOWERED BY THE HOLY SPIRIT

Through the pipes flows the Holy Spirit to empower us, the broken people and fallen creation.

Christian life is an "impossible journey" without God's supernatural intervention. We are told "be perfect, as your heavenly Father is perfect" (Matthew 5:48). Jesus says this just after he challenges us to love our enemies, which seems outlandish in a world filled with enemies who threaten our existence. The Holy Spirit, given as a gift at Pentecost, makes this impossibility a possibility on this side of eternity. The history of the church depends on this shift, of ordinary peoples of the Galilean hills to be transformed into the Way that reshaped the world. The Spirit sheds light on Jesus, to allow for us not just to imitate Jesus, but to have a new identity in Christ, with full redemptive power to live and die as Christ. This same Spirit filled the disciples, who failed repeatedly and hid themselves away to avoid persecution; the Spirit transformed them

to be the bold leaders of the early church. The Bible does not shy away from describing their miseries and series of failures. It depicts how these flawed, limited men and women from fishing towns were transformed into leaders who changed the world.

In the centuries since then, many church bodies have recognized the role of the Holy Spirit in our worship and our growth as believers. Movements such as the Pentecostal movement have acknowledged the Spirit's power. The ultimate fruit of the Spirit is "love—joy, peace, patience, kindness, goodness, faithfulness, and self-control" (Galatians 5:22–23, my paraphrase). All of these words to describe the fruit of the Spirit can be read as Making words. The term "fruit" is a generative word, on which my thesis of culture care is based. Therefore the empowerment of the Spirit gives us power not just in its conventional sense, but also in the sense "of love, and of a sound mind" (2 Timothy 1:7 KJV). The Spirit allows us to live relationally and imaginatively with God. This claim sounds outrageous to many outside of the Christian faith, and yet the Spirit invites us to co-create into a fullness of life (John 10:10).

RESTORED BY THE BLOOD OF CHRIST

Through the pipes flows the blood of Christ to restore us and rejuvenate the earth.

Christ's redemptive work on the cross, Christ's bloodshed, becomes an entry point of faith for all of us. Even if we struggle to "know God" or to "feel God," historical reality requires us to ask, "Who is this Jesus?" There's ample evidence that Jesus of Nazareth existed in first-century Palestine, that his actions and his own declarations pointed at him to be the Messiah foretold in the Hebrew scriptures for thousands of years, and that he died a criminal's death. Christians offer that this death was the "death of Death" and that Christ's blood cleansed all of us

into a new relationship with "Abba," Father, the Maker of heaven and earth.

The pipes of the New Creation continue to carry the redemptive blood of Christ to restore us. All of us need constant restoration to keep on the path toward the perfection of Christ. The blood of Christ also rejuvenates us; in worship, especially through the Eucharist, it seals us and heals us for our redemptive path. In other words, God's restorative work continues in us, and God has promised through the blood of Christ that this is part of an everlasting covenant.

TASTING THE WINE OF THE NEW CREATION

Through the pipes flows the wine of New Creation to invite us into the feast of the New. But the wine of the feast will flow backwards from New Creation to our reality.

As Christians, we can begin to sup on the feast to come, even though our vision of it is limited on this side of eternity. The arts—even as done by nonbelievers—celebrate this feast to come.[5] Examples such as Isak Dinesen's story "Babette's Feast," Ernest Hemingway's *A Moveable Feast,* and Olivier Messiaen's *Quartet for the End of Time* all point to the feast, even as they depict fissures of trauma in the twentieth century. These artists remind us that "a great artist . . . is never poor" (as Babette states) and that we need music and theater not just for entertainment, but as a proven way to survive our traumas, even in the most severe trials, such as the Nazi concentration camps.[6] Art literally feeds us through beauty in the hardest, darkest hours. Christians can have a foretaste of what is to come by celebrating through making and through the exegetical work of culture. Through this wine of New Creation we can be given the eyes to see the vistas of the New, ears to hear the footsteps of the New, even through works by non-Christians in the wider culture.

Robert K. Johnston speaks to these issues in his 2014 book *God's Wider Presence*. He studied the Spirit's work in the wider culture, such as films made by non-Christians. He offers many examples of non-Christians having "God encounters" through cinema. Oftentimes, though, they do not tie this directly to a Christian church, nor are they willing to walk into one. What if the Spirit operates outside of the doors of the church to speak to thousands without their knowing it? The Spirit does not read "labels." In other words, the word "Christian" used as a mere label does not mean anything to the Holy Spirit, who hovers near people who authentically, earnestly wrestle with truth, beauty, and goodness.

Labeling as "Christian" what we have done does not mean anything. Just because someone does not see herself or himself as a "Christian" does not mean that the Holy Spirit cannot effectively speak to that person. The wine of New Creation already flows into all of our lives through culture. Of course, not every offering is beneficial or edifying. All works, whether done by Christians or non-Christians, will be tested. Such refinement already, in some ways, has begun.

THE BEAUTY AND MERCY OF CO-CREATION

The inherent danger in focusing on our making is that we may make more of our making than what God intends—that we may create idols of our art, or of our "making" abilities. God invites us to co-create, but that does not mean that we are the ones to create the New Creation; only God can do that work.

Here, then, is a central parable for our Making journey:

Imagine a father taking his child to the beach. The father watches his child make a sandcastle, which will be washed away by the high tide.

But this father happens to be an architect. Imagine that this father loves his child so much and is astonished at the design of the castle that his child has made.

Several years later, the child looks in amazement as the father creates a real castle that is based on the sandcastle that the child created.

This may be close to what the New Creation will be like. God desires in God's heart to be with the child as the child plays on this side of eternity. God chooses, out of God's gratuitous heart, to co-create into the New World. There is no particular need for the architect father to create an actual building, but the father re-creates in love, and he has the power to do so. The New Creation is filled with such attentive, self-giving outworking of God's love toward us.

But there is more to the Theology of Making than what this simple metaphor can communicate. What if the father were to create a building using sand, the very material the child plays with? Transmuting it into an actual, permanent building would, in a sense, make the castle that washed away into a new reality that surpasses the creative capacity of a child on the beach. However, that castle would not—could not—have been built unless the child had initiated building it, even though that child never assumed it would be permanent. The lesson here is that God takes far more seriously than we do what we make, even in "inconsequential play," and everyday realities can be enduring materials through which the New Creation is to be made.[7]

THE ECOSYSTEM OF NIHONGA

Nihonga, the Japanese style of painting that is the lineage of my approach to art, is very hard to teach outside of Japan. It involves an ecosystem of trained craft folks of multiple generations, from paper makers to brush artisans, and that ecosystem is built on trust and relationships.

Nihonga, to me, is to "play with sand"—very beautiful, pulverized, valuable sand.

I am often asked to do workshops on Nihonga, but I rarely can. People assume that Nihonga is about the materials and tools—that we can learn it by taking lessons and sharing recipes. But a recipe or a formula alone cannot make art. I have come to believe that Nihonga is part of the historical ecosystem of care and nurture of culture that the Japanese have cultivated for more than a thousand years, an integrated way of making that affirms the beauty of nature. Nihonga is impossible to teach outside of that ecosystem.

However, we can learn from Nihonga that the process of creating provides an organic, hands-on, and communal approach to knowing. The body of Christ provides the Christian ecosystem for teaching the New Creation, and this can happen if the church once again becomes a place of making, the heart of beauty in the world, and a witness to mercy. As hard as it is to do a workshop representing a millennium of wisdom and the ecosystem of Nihonga, it is harder to communicate the gospel in the fullest sense.

The book of Psalms, God's poetry, gives us an ecosystem of metaphors and a garden of words to describe the thriving offered to us in the New Creation. Scholar Ellen Davis observes that reading passages of biblical poetry gives us access into the Bible's multiple layers in a "surplus of meaning": "it [the Bible] may mean more than one thing at any given time. Further, it can speak to different audiences in varying ways through the centuries. In that sense, all of Scripture is poetry, and surely its inexhaustible potential to say something new and stunningly apt is a large part of what we mean when we call the Bible the word of the living God."[8]

In other words, God created the world through poetry and incomprehensible beauty. Our plumbing theology has narrowed our field of vision; instead of perceiving this extravagant act of Creation, we persist in

our "fixing" mentality. Of course, we have to contend with the fact that our fallen nature has had a disastrous effect on Creation and ourselves. What the Bible calls "sin" is to act aberrantly to the true identity that we have in Christ. What is beautiful is that even in such brokenness, God reveals grace.

As part of a collaboration with Ellen Davis, I will spend a decade or more creating a journey into the Psalms. My part in this collaboration is to paint 150 paintings, one based on each of the psalms, one psalm per month, each forty-eight by forty-eight inches square.[9] These images will not be "illuminations," as in *The Four Holy Gospels* project, but meditations; and having begun to paint, I have learned that the project is a good discipline for me to slow down and spend time with the poems of God's heart. I am using materials that require me to slow down: sumi ink (sticks made from pine shoots that I must rub against a stone for more than an hour) and oyster shell whites (pulverized oyster shells that require more than three years to create and that take me a day and a half to reconstitute). I also am using platinum and gold powders, two Nihonga materials that are considered the most difficult to use.

AUTHORITY TO MAKE

The word "authority" has become an allergen to youth culture, or even in the culture at large. Our bristle against this word stems from the abuses of institutions, including churches. But here again, this book suggests a new lens through which to see even this word. We can think of authority as author-ity. The discipline of Making involves author-ity. Mastering Nihonga materials, or any other medium, requires an "author" master who can provide author-ity to the expression. As I journey with the Psalms and other scriptures, I am convinced that God, the ultimate Maker, is the only Author of our lives and our world. The Theology of

Making restores the author-ity to the rightful Author and sees all things under this light of goodness. Such an Author can make new all things, and in doing so can make brokenness shine in new ways. It's extraordinary to me that God, with this authority, would give authority to us, just as God gave Adam full author-ity to name the animals in Genesis 2. This understanding of the connection of sacrifice, brokenness, and redemptive purposes has a surprising parallel in Japanese culture—the extraordinary cultural parable of *Kintsugi*.

4

Kintsugi

THE "NEW NEWNESS"

In the Christian journey, the greatest triumph, the bodily resurrection of Christ from the grave, is not the "happy ending" of a fairy tale, but only the beginning of the New with the entry point being suffering and persecution. The greatest miracle is turning our "hearts of stone" into "hearts of flesh" (Ezekiel 36:26). When we encounter God in the darkest moments, really in the depth of our depravities and soul's death, we are given such a faith to believe our God—despite what we see and who we are, despite how difficult and dark the world gets—and faith given by grace will not fail us.

Yet our struggles are deeply embedded in our journeys. The darkness in our world can also take up residence in us. In Eden, we (collectively represented in Adam) were enticed by the subtle message of the agent of darkness that whispers in our hearts that we "do not need God."[1] That pride caused our desire to see the precious "bowl" of life as our own invention, and we could not keep that which we consider to be precious, as our lives are marked by things undone and done, as the Book of Common Prayer notes: "We have left undone those things which we ought to

have done; And we have done those things which we ought not to have done." Saint Paul writes of this conundrum in Romans 7:

> So I find this law at work: Although I want to do good, evil is right there with me. For in my inner being I delight in God's law; but I see another law at work in me, waging war against the law of my mind and making me a prisoner of the law of sin at work within me. What a wretched man I am! Who will rescue me from this body that is subject to death? (vv. 21–24)

We cannot even keep the promises we make, let alone the promises God commanded us to keep. Even our deepest desires are disordered, "waging war" against the "law" of the mind. We are wretched, broken fragments of what was once beautiful. Trying to do our best to obey God's laws has failed us, as even if we think we can keep the law, keeping it can lead to pride and legalism.

This is the greatest "proof" of the resurrection—not the immediate material proof of triumph, which also can be provided and argued for, but what happened to the disciples, who failed over and over and fled when they saw their teacher being captured, tortured, and dying in front of them in the greatest humiliation. They thought that Jesus was leading a political rebellion against the established order, but they were badly misinformed. On Palm Sunday, everyone celebrated Jesus and his "triumphal entry" into the city, and yet Jesus wept on the hill overlooking Jerusalem. Jesus wept because he saw that the same lips that praised him soon would turn to curse him on the cross; Jesus wept for Jerusalem, a city that would endure many betrayals and corruption and that his followers would be powerless to protect. It is in the tears of Jesus that we see both the extravagant gift of God's presence in our world and that gift of grace which defines the humanity of God. (I will extend these thoughts further in Chapter 8.)

Those who betrayed, those who ran away, those who could not be courageous when courage was needed—something happened to their wretched hearts after the resurrection. They had experienced the Light breaking through that Easter morning; the rock was moved and the seal was broken, but they also began their journey of the New through the deepest realm of their failures. And so it is with us: through the fissures of our broken journeys, with pieces of our own hearts shattered on the ground, we journey by God's grace into the New Creation. God sees beyond our shattered remains. He picks them up and sings a song over us.

KINTSUGI THEOLOGY:
MENDING THAT LEADS TO THE NEW

Kintsugi, the ancient Japanese art form of repairing broken tea ware by reassembling ceramic pieces, creates anew the valuable pottery, which now becomes more beautiful and more valuable than the original, unbroken vessel.

Kintsugi is likely to have been refined out of the tea culture of the sixteenth century and the aesthetics of Sen no Rikyu, the most important tea master of Japanese history. The historical tale speaks of Yusai Hosokawa, one of the key tea masters of Rikyu's era. When he was to prepare tea for the warlord Hideyoshi, Hideyoshi's young attendant dropped an invaluable piece of tea ware, one of Hideyoshi's favorites, breaking it into five pieces. Hideyoshi raised his hand to punish the servant, but Hosokawa intervened, singing a poem that echoed a ninth-century *waka*. The improvised version used a romance poem between two childhood friends courting each other as adults, but a turn of phrase transformed that romance into a sacrificial mercy toward the young servant. Hosokawa, by singing this poem, basically atoned for the young servant and

took responsibility, saying, "I will be the one to be blamed for his mistake." Artfully done, this clever turn of phrase spared the servant. Later, Hosokawa arranged for the five pieces of pottery to be reconnected using the *Urushi* Japan lacquer technique with gold gilding and presented it to Hideyoshi. The warlord was moved by the beauty of Kintsugi tea ware, and the story became renowned. This act of compassion became the basis of Kintsugi, which added gold in the Urushi filled cracks, creating a work of beauty through brokenness.

Another anecdote tells of an earlier story of Kintsugi.[2] When Shogun Yoshimasa Ashikawa (1436–1490) sent broken fragments of tea ware to China, the bowl was "fixed" with metallic staples and returned. Dismayed by the effort, the warlord instructed a potter to find a better way to restore broken bowls using gold. In both of these anecdotes, what is important is that the aesthetic of Rikyu refined the Kintsugi technique and aesthetic as part of Rikyu's effort to elevate the value of tea ware, many of it Korean, in a country that was intent on invading neighboring countries, including Korea. Many of the tea masters, including Rikyu and Furuta Oribe, were forced to commit ritualistic suicide because of their opposition to the dictatorial powers of invading countries. Kintsugi, as well as the art of the tea ceremony, was always part of the aesthetic of peacemaking.

The Japanese *kin* stands for "gold" and *tsugi* means "to reconnect," but *tsugi* also has, significantly, connotations of "connecting to the next generation." A Kintsugi master mends the broken tea ware with Japanese lacquer and then covers that with gold. Tea master designer Hon'ami Koetsu (1558–1637) saw the broken shapes of valuable tea ware as invoking landscapes and is known to have contemplated them before applying Kintsugi. Kintsugi does not just "fix" or repair a broken vessel; rather, the technique makes the broken pottery even more beautiful than the original, as the Kintsugi master will take the broken work and create a restored piece that makes the broken parts even more visually sophis-

ticated. No two works, done with such mastery, will look the same or break in the same way.

So, too, the biblical passages of restoration. I stated earlier: "Seeing the redemptive act of God, the ultimate act of Christ's sacrifice on the cross of Calvary, through the lens of Creation and the Holy Spirit's work awakens in us the potential of the New Creation." The example of Kintsugi captures, and enlarges, this promise. The Christian gospel, or the Good News, begins with the awareness of our brokenness. The Fall created a schism between humanity and God caused by our desire to become like gods. Christ came not to "fix" us, not just to restore, but to make us a new creation. Christ's sacrifice at Calvary means he died to take our place in receiving the death we deserve; he took on the cross for our sakes and became the sacrificial lamb for us. Christ's "substitutional atonement" will restore Creation and us into the right order of God.

The biblical vision of the new world accompanies the reminders of the wounds of Christ. The resurrected Christ still bears the wounds of the crucifixion. Through these sacred wounds a new world is born; through the revealing of the wounds still imbedded in the new body of Christ, our faith is given (see John 20:24–29 for the resurrected Christ's encounter with Thomas). The Theology of Making captures in part this paradox of destruction and of New Creation.

WHAT RESURRECTION LOOKS LIKE

At the heart of our journey toward the New is the resurrection vision of God. Every art recognizes that the work must be broken to be made new again. Minerals must be pulverized. Characters of a play must be tested beyond bearing. "To be or not to be, that is the question," we cry with Hamlet in desperation. A dancer's body will be broken over and over again for that one miraculous leap. In that journey of brokenness, we

experience something that transcends the brokenness. In that signature of the New given birth through darkness, we recognize a mark of greatness given to an enduring art worthy of all of our attention.

Even "fixing" what is broken is an opportunity to transcend the "use" of the object. Kintsugi bowls are treasured as objects that surpass their original "useful" purpose and move into a realm of beauty brought on by the Kintsugi master. Thus, our brokenness, in light of the wounds of Christ still visible after the resurrection, can also mean that through making, by honoring the brokenness, the broken shapes can somehow be a necessary component of the New World to come. This is the most outrageous promise of the Bible, which is at the heart of the Theology of Making: not only are we restored, we are to partake in the co-creation of the New.

As border-stalkers, artists are often found at the margins of society, meandering into the borders of established thought patterns, or, in the case of Vincent van Gogh, established ways of painting.[3] These border-stalking voices are essential for a Kintsugi mode of theology that mends the broken fissures of our cultures and helps all of us to listen to the voice of the Spirit.

Border-stalkers have the ability to learn and communicate extratribal languages, and they can transcend tribal norms. It's important for them to see that they often find themselves alone, and they need to learn to travel "two by two," as Jesus instructed us in Luke 10:1. We have the capacity to adapt to extratribal realities, but the borderlands are also dangerous places, as we are exposed to both the cultural storms and forces of destruction. But the border-stalkers are increasingly valued in cultures that are polarized and have created false dichotomies, as these artists can help to mediate the divided realities and bring the wholeness of the gospel message.

A "NEW NEWNESS"

In 2 Corinthians 5:17 (ESV), Paul states: "Therefore, if anyone is in Christ, he is a new creation. The old has passed away; behold, the new has come."

Kainos is the Greek word used here for "new creation," but when we hear the word "new," we immediately think of something being improved, as in a new iPhone or a new car. The Greek word for an improved device would be *neos*, from which we get the word "neon." That new fashion, or new technology, is flashy and will illuminate our culture for only a short time. *Kainos* is categorically different from *neos*. I interpret *kainos* to be a "New Newness"—akin to a caterpillar becoming a butterfly, but more. Yes, it is transformation, but it is more than that—it is transfiguration (the Greek word *metamorphoo,* of Romans 12, is used in the Bible and commonly translated as "transformation"). I may even go further and say that *kainos,* in the way that Paul uses the term in 2 Corinthians, is not just a new species, but a new concept of what a species is. Paul is describing how we are a "new [*kainos*] creation" as the resurrected Christ enters our lives.

Later in this book I explore some philosophical reasons behind how we create binaries to help us understand these concepts, but our assumptions blind us to the powerful resurrection truth behind them. The reason for this necessary discourse is to prepare us to think outside of outmoded dichotomies that we have created in our culture—false dichotomies that make it impossible for us to even speak of a transformation that leads to the transfiguration of the resurrection to come. When I speak of generativity, I am speaking of the potential that each one of us has, even in our ordinary days, to attain this New Newness. I believe such potential is often whispered at the margins of human experience, in the gratuitous, in the discarded, in the exiled voices of poets and artists, often working

among the poor and the oppressed. All artists seek the New; great ones redefine what Newness is.

This New Newness breaks into our lives through Christ. Christ's death on the cross is a new beginning; Christ's resurrection is a new beginning. Pentecost is a new beginning; the Ascension is a new beginning. It is more than transformation: it is really *metamorphoo*, or transfiguration. The Bible is all about these "new, new beginnings"; the Bible is about us being transfigured by Christ.

Art taps into this New Newness instinctively. An artist hovers in between what is conventional and what invokes the future. The artist seeks the new but can often be conscripted by market forces to stay in the *neos*. Our journey of faithfulness encourages art to be created in the mode of *kainos*, as art needs to redefine art in a new sense if that work is to be enduring. While this journey to help artists develop a sanctified imagination in specific fields is outside the discourse of this book, it is not outside the goal of this project.[4] We need every practitioner, curator, and cultural institution to create a safe place for artists to experiment and grow in this sanctified imagination. This can start within churches, but I advocate for a general cultural practice that also works outside of church walls.[5]

VISITING A KINTSUGI MASTER

Nakamura-san, a youthful Kintsugi master, welcomed me into a small café in the middle of Tokyo that he calls the Sixth Dimension café.[6] As I sat in the midst of books and vinyl records, with whiskey bottles and the smell of coffee, a local commuter train went rushing by the window. "Some people find it noisy with the train, but I do not," Nakamura-san said, with a gleam in his eyes. "This place, you can bring any type of noise with you, and it will collide and be canceled out because of the constant,

familiar sound of the train going by. Because it's so tiny, people have to get to know each other."

Indeed, the place must have been no larger than four hundred square feet, but here, on a naturally split wooden table, were the Kintsugi bowls that he had been working on. "I do not like to work alone," he said. "I like to invite others, even those who may not have any experience, to join me."

After conversing for more than two hours that hot July afternoon, I began to have my own version of translating what "sixth dimension" meant for me. We live, let's say, in the third dimension, trying to deal the best we can with time and space. The idea of Kintsugi mending, of restoring the broken bowl, then, perhaps is the fourth dimension, in which we move through our pain and trauma into a beautiful place. The fifth dimension, in this scenario, will be what Nakamura-san showed me next: an eighteenth-century teacup mended with early twentieth-century fragments filed to fit the broken area. This is called *Yobi-tsugi*, literally, "calling into" mending. The work looked like a quilt, with the bright patterns augmenting the old design. "It's like a collage," I noted, feeling the edge of gold carefully mended, and the teacup seemed to wink at me.

In the days of postcolonialism, we need to find our own mending to be a collage-like journey toward healing. The resulting patterns will not be, by design, to restore the old days of national glory, but a beautiful amendment that resonates under a master's hand. Yobi-tsugi can also mend the fissures of two warring nations, as in a video Nakamura-san created in which he mends together ceramic fragments from North and South Korea, or from Pakistan and India, with the edges matching the shapes of the countries' geographic borders and a "river" of gold flowing through them.[7] Yobi-tsugi is a master art for peacemaking.

But, as he moved deeper into a cabinet that held many of the fragments to be repaired, Nakamura-san opened up for me a sixth dimension of Kintsugi. "I go to antique stores and look for very old objects that are

broken—some of them, shards like this." He handed me a green porcelain that seemed to be from twelfth-century China. "I hold this broken shard, and spend time imagining the bowl," he said. He then handed me an earthen vessel that was completely round in the bottom. When I held it in my hands, it felt almost like a small soccer ball but had the warmth of rough-hewn clay.

I tried to guess the age of the object and was astounded when he said, "This is from the Jomon period, roughly ten thousand years old." The vessel was broken in corners, but I could still sense the wholeness, and the hand that had shaped it. "It's amazing that something like this, I look for and can afford because no one wants a broken pot!"

What is the sixth dimension? Well, it's the Kintsugi master searching for fragments and broken pots, not for the purpose of mending them, but for contemplation. In fact, when I held this earthen vessel, I was, indirectly, touching the hands that made this earthenware, hands that had nurtured and used the bowl every day. A visceral communication spanning thousands of years went though me like I was now holding hands with the maker of this pot. Nakamura-san quipped, "I wish children could go to the Raku Museum and touch the bowls; that's the only way to appreciate them."[8] I nodded, continuing to marvel at the experience.

Jesus seeks the one lost sheep and leaves the ninety-nine behind. The ultimate act of a Kintsugi master is not to even attempt to fix the broken vessel, but to behold its potential, to admire its beauty. What kind of a church would we have, I pondered, as I rode the commuter train back to Shinjuku Station, if we sought the sixth dimension in our churches? What kind of a church would we become if we simply allowed broken people to gather, and did not try to "fix" them but simply to love and behold them, contemplating the shapes that broken pieces can inspire? What type of a bowl would their hands make, a visceral communication that can be passed on for ten thousand years?

THE VALUE OF PLUMBING

Having advised a cautious approach to the overemphasized plumbing theology in our times, I must emphasize the need and value to have roles in the creativity that is birthed out of a need to fix a real thing that is broken. Plumbing is to be valued, and a good plumber can fix our pipes—but a great one can take it to the level of artistry and even hospitality. I can imagine there may be a Kintsugi plumber in the world! The embodiment of the often humble act of repair is one of the mainstays of human goodness and stewardship. The "fixing" analogy assumes that something went wrong and that which is broken needs to be repaired. The Christian message of the Good News has at its core the message of our fallenness—that we have committed both sins of commission, doing things that we know we should not do, and sins of omission, failing to do things that we know we should do (in the words of the Confession in the Book of Common Prayer). Both kinds of sin grieve the Creator God. "For all have sinned and fall short of the glory of God," Paul laments (Romans 3:23); "what a wretched man I am!," he confesses (Romans 7:24).

Yes, Jesus came so that we can be redeemed from our brokenness, so that "there is now no condemnation for those who are in Christ Jesus" (Romans 8:1); and his death at Calvary was an act of a true Son of God who came as a sacrificial lamb to receive the penalty that we deserve for our fallenness and willful ignoring of God's ways. In Christ, there is eternal forgiveness and restoration of the relationship between us and our Creator, but also empowerment through the Spirit to live the lives that we ought to have lived. Even in the midst of our brokenness, we can wake up each day to a universe brimming with abundant grace because of Jesus.

When I say that a theology toward the New Creation moves us

beyond the "fixing" arena, I am not in any way discounting the redemptive path that Christ paved by suffering and giving his life for us; rather, this journey helps us recognize why Christ came to the world in the first place. In this discussion, I desire to honor the redemptive act of Christ as being an active agent of both justice and Making (*poiema*) the New (*kainos*) in the midst of the broken world. As I've hinted earlier, this Greek word *kainos* that Paul uses means "perpetually New" or "eternally New," which is different from the typical sense of "newness" expressed in the Greek words *chronos* ("linear, progressive time") and *neos* (neon-like, momentary newness). Christ came not just to fix the world and take us back to Eden or to paradise; Christ came to bring into existence a New (*kainos*) Order, a New Creation. This book and conversation assume that the New is breaking into the old, broken earth. The narrative of the Bible always leads to Making in this New Newness; the Bible posits a path, one might say, of "mending that leads to Making." Thus, in my understanding, being redeemed includes this act of Making, an invitation to the New. Making necessarily depends upon the work of the Holy Spirit in our lives and in our creativity; the Holy Spirit–filled life of abundance (Galatians 5) leads us into the recovery of ourselves as makers in the image of the Creator.

This act of Making starts by becoming aware of God's presence in the midst of our brokenness, through the recognition of our need for God. The most mundane acts can be filled with the presence of God (even washing dishes, as Brother Lawrence observed in the 1600s).[9] It is precisely through our brokenness and fissures that God's grace can shine through, as in the gold that fills fissures in Kintsugi. The tea bowl that is mended the Kintsugi way is once again used in a tea ceremony.[10] This is why the laborious process of Japan lacquer is used, rather than, let's say, the expedient super glue.[11] Japan lacquer is natural and can mend so that the bowl is perfectly safe to be used again. It is the "resurrection" into use again of what is broken that is profoundly at the heart of Kintsugi.

But such art is "slow art," sometimes involving generations of families of tea masters.

Redemptive and restorative acts are the signs of the New Heaven and the New Earth. Through the fissures of our broken bread and poured wine of sacrifice, we can begin to see the New. Even through mundane acts like washing dishes, we can recognize the New World breaking into our journey in the fallen reality. We can begin to see the value of cultures, races, and even acrimonious divisions. In these days of #BlackLivesMatter and #MeToo, it's important to remember that the goal of such movements is not to fix an inequity, but to seek a new way for us to see beauty—as in "fair-ness"—in all peoples. Again, in Christ, we are a New Creation. My daughter, who is an organizational psychologist, has led her church in the effort to build peace between Israelis and Palestinians by bringing together those who have lost loved ones from both sides. She recently texted me this statement about "common ground" that builds peace: "Common ground is not simply middle ground—not simply waiting to be found, but waiting to be created. Artists create this new ground for culture and society. And teach others how to create, through their creation. As you know :)"

This common ground that is not "simply waiting to be found, but waiting to be created" is the Kintsugi fissures that can be filled with gold. This New Creation through the common ground also retains the wounds of the distinctions we hold on this side of eternity, just as much as Christ's redeemed body still holds the wounds from Calvary. So whether the wounds we bear in this world come from discrimination, injustice, or inequality, they may be the path through which we find common ground and sacrifice. In the fissures of a Kintsugi bowl is an opportunity "waiting to be created."

In the well-known story of "doubting Thomas" (John 20:24–29), the resurrected Christ invites Thomas to touch his wounds. Thomas does not; instead, he kneels down and worships Christ. Perhaps we should

reframe our view of this apostle and begin referring to him as "believing Thomas." After all, once the invitation was given, Thomas felt no need to actually touch Jesus's wounds. His faith allowed him to move beyond the "proof" of God's promise; he believed the risen Christ to be true and real. Faith can forgo the somatic way of touch, the path of physical knowing, by acknowledging and trusting the resurrected Christ in front of us and recognizing the New already present. Such a recognition leads to worship. In the New, we can bypass the proof of scientific knowledge if we experience the presence of the resurrected Christ all around us. In the same way, our past and present preoccupation with "proving" God's existence to atheists may not be as effective a way of persuading the dying world as creating through our God-given imagination to worship and create into, and recognize, the New standing in front of us.

At the same time, we must also realize what the sacred wounds of Christ remind us of—that they exist because of our failures to honor God.

N. T. Wright notes: "following the disaster of rebellion and corruption, [God] has built into the gospel message the fact that through the work of Jesus and the power of the Spirit, he equips humans to help in the work of getting the project back on track."[12] This work away from "rebellion and corruption," our efforts, will never replace what God will do to "bring unity to all things in heaven and on earth under Christ" (Ephesians 1:10). But we are to work on this side of eternity in the anticipation of the New World to come; we are to "build for the Kingdom." Building for the Kingdom is the act of the ultimate Kintsugi master, Jesus; and it is through his wounds that the New Creation begins.

In building for the Kingdom now, we must move beyond the goal of fixing things and instead set our hearts on the art of Making. Again, redemption is more than fixing; it is a feast of healing and transformation. Redemption is being part of God's art toward the New Creation. But the path toward the New Creation weaves through the brokenness

of our world, our own lives, and the fissures created by various factions of faith institutions. We may not need to provide the world with proof of God's existence, or to coerce others to see the reality of God as we experience life, if we are Making generatively. Perhaps, instead, we need to create and make through the fissures of our lives in an authentic way. Then the word "fix" will have a meaning beyond mere repair, as we shall see. Such understanding can illuminate the Kintsugi path toward the New Creation. The Spirit of the New Creation will lift us toward such a profound reality.

Bishop Wright writes about three paths that he believes can invoke the New Creation into our old Creation, to advance the Kingdom to be unloosed on this side of eternity. The first path is mercy and the work of justice; the second, beauty; and the third, evangelism. By making, we actualize all three activities at once. We do this not by the utilitarian, industrial path but through the Kintsugi path, or "evangelism," by programmatic information sharing only. By art that leads to Kintsugi Theology, we acknowledge the broken realities of our wretched condition but work to mend what is broken. By Making toward beauty in the context of brokenness, through sanctified imagination, we are proclaiming God's Good News. How? Evangelism is the proclamation of the New. To use another metaphor to accentuate this Kintsugi Theology, by "fixing" the soil of culture, as farmers do their fields, we are on our way to realizing this invocation of the New.

"FIXING" THE SOIL

I hold in my hands the red clay soil from my garden in Princeton. In the summer sun, goldfinches fly past me in a group, hovering and then perching sideways on the stalks of sunflowers that still have seeds. Living in New York City for many years, I've never really had the opportunity to

touch the soil, to garden, or to see goldfinches dash about in their summer splendor. My move to Princeton, coming out of lingering trauma, has resulted in my hands coming to "know" the soil. This has been my Kintsugi journey to a new home.

Farmers, I discovered in the Garden State, "fix" the soil; they amend it to create biodiversity in their fields before they plant their crops. It's implicit in the Parable of the Sower in Matthew 13 that the farmer has spent much time preparing the soil before going out to sow the seed. It's important to realize that this story does not question the viability of the seed; the "seed," in this case, is the gospel of Jesus, and therefore it is perfect. This parable doesn't hinge on what type of seed the farmer plants, or on what kind of a person the sower is. The sower represents Christians, or Christ himself, sowing to renew the earth and give life to people. No, this parable is all about the soil. As I have worked at my small farmhouse in Princeton, I have spent much time failing to produce crops, so I know now that the key to farming is the soil. This famed "Parable of the Sower" is really the "Parable of the Soil."

Soil is something we do need to "fix"—both to remove rocks and, in a deeper sense, to amend and nourish it to prepare it for the spring. Farmers plant cover crops such as alfalfa or winter rye to produce airspaces in the soil and generate nitrogen. This needs to happen before the wintertime, seemingly a dormant season, but the nutrients created provide ample activity under the soil's surface. If this fixing of the earth does not take place before the seeds are sown in spring, then the seeds are less likely to take root. Fixing the soil can also prevent thorns from choking the growth of the crops.

Note that this process is not restorative; it is a kind of new creation. For a farmer, "fix the soil" is generative language—"Kintsugi language," one might say. In other words, this act of fixing the soil does not simply restore something; it renews the soil and makes it more productive than it was before. The parable in Matthew 13 reminds us of two things: what

makes the New Creation possible, and what can prevent the New Creation from occurring. "Fixing" is part of stewardship of the soil, and we can apply this directly to our lives and our cultures.

We find agricultural metaphors in Paul's writing, too. In 1 Corinthians 15:36, he mentions the process a seed goes through to root and says, "What you sow does not come to life unless it dies." Here, Paul is using this as an analogy for the process toward the New Creation. A seed dies not just to "fix" the earth, but to generate new life. If we do not plant seeds after tilling the soil, we will miss the harvest. The brokenness we experience in life can be part of this "death" into the fixed soil. The soil of culture and life that we till becomes the bed in which we can be laid to rest. If we can humbly be buried deeply into the soil of death, then life can begin through the composting and regeneration of the soil of culture. In that sense, the gold that fills and reunites pieces of pottery is similar to the microbes that regenerate life in the soil. Kintsugi mirrors what well-cultivated soil does naturally within its dark realms. In the hard winters of nature and the hard winters of our lives, we anticipate what will come: the infusion of golden, heavenly reality into the broken, death-filled soils of our lives and culture. Kintsugi gold flows all around us in cold, hardened winter soil.

As the theologian Ellen Davis has so persuasively written in her book *Scripture, Culture, Agriculture: An Agrarian Reading of the Bible,* unless we grasp agrarian preconditions, we cannot understand biblical stories at all. We must realize that in our postindustrial mindset, we understand everything we touch to be a commodified mechanism of utility and efficiency. Jesus appears as a gardener after the resurrection, not as an industrial Lord. What I call "utilitarian pragmatism" works against our humanity and against agrarian ethics and will resist the advancement of the Spirit's work already embedded in culture. The biblical gospel could be seen as an injection of the seed of life into the stressed soils of our culture. Davis also states that poetic language is the basis of much of the

Bible; agrarian practice and poetic metaphors both point to the Bible as a "Making" book.

Jesus uses poetic language and storytelling in the Parable of the Sower to give us a fuller picture of what he came to do. He calls us to action, but he does it by invoking a metaphorical, allusive journey. In order to be a sower of the Kingdom, each of us must become a farmer-poet. Perhaps that is why the passionate paintings of Vincent van Gogh speak to our hearts so much, as he identified with lowly workers and peasants as an artist. His painting *Starry Night* could simply be the most effective vista, or even evangelism, of the Good News of the New (*kainos*) reality breaking into our darkened churches (like the one at the heart of the painting) that anyone ever could have offered.[13] Perhaps this fuller picture is why the writing of Wendell Berry, the ultimate farmer-poet, speaks to us so deeply. His Port William series of novels, including his masterpiece *Hannah Coulter*, "practices resurrection" through minute, even mundane, observations about the small town of Port William in Kentucky. Perhaps an artist's "sower" language hints at the reason for the resurgence of interest in Emily Dickinson in our time. Her "Tender Pioneer," Jesus, is calling us to a deeper integration of the way we hear a message, the way we may understand our world. He is calling us to a deeper, integrated poetic knowledge that leads to the agrarian ethic of the Kingdom. He is calling us to the deep resonance of the Spirit, already at work to create the New.

Emily Dickinson, Vincent van Gogh, and Wendell Berry are three examples of artists who speak profoundly to our journey as Christians. I've discussed their influence elsewhere; here, I simply suggest that the Theology of Making can be explored using art and poetry as starting points. Poets and artists are heralds of the New. Embedded, incarnated artworks that are authentic to the "fuller picture" journey into the sacred Kintsugi works of God can help us to understand the conditions of the soil or modern culture, and thereby help us to communicate, and commune, into deeper cultural means for the advancement of the gospel.

This combination of the reparative (restoring the object's utility) and the generative (increasing its beauty and value with gold) speaks to the deepest realm of Kintsugi. We would be wise to consider our own brokenness in light of the wounds of Christ still visible after his resurrection. When Making honors brokenness, the broken shapes can come into focus as necessary components of the New World to come. This is the most outrageous promise of the Bible, which is at the heart of our journey toward the New: not only are we restored, but we are to partake in the co-creation of the New through our brokenness and pain.

In the lingering trauma and pain that I've experienced recently, as I prayed one snowy morning in Princeton, it occurred to me that God has beheld me, a broken vessel, just like Nakamura-san, the Kintsugi master, holds tenderly the fragments he collects. God's "collection" includes all of my joys, loss, and pain. I realized that I, too, can be beheld, not as I will be, but as I am at this very moment. A journey toward the New begins with such an experience of raw authenticity of brokenness, tears, and healing.

5

Caring and Loving, the Work of Making

I hold three fresh eggs from my Plymouth Barred Rock chickens; the eggs are still warm in my hands. I want to make the best omelette possible with the fresh eggs. So I do some research and come up with YouTube videos of French master chef Jacques Pépin making omelettes. I watch this video over and over and follow the recipe precisely. But no matter how many times I watch the video, or read the recipe, I find it difficult to make a simple omelette the way he does it so effortlessly. A recipe for an omelette is as simple as it can get. But information about how to make one does not readily translate into the actual making of the thing.

In other words, there is a huge gap between informational knowing and the actual knowing of making. The same can be applied to theology. There is a huge gap between knowing theological concepts, or what Christians call the gospel, and the actual practice of knowing.

The philosopher Esther Meek states, "If knowing is care at its core, caring leads to knowing. To know is to love; to love will be to know."[1]

Caring and loving are the fundamental elements of the act of making. We need to be connecting the revelation of God as the Creator in

Genesis 1 with 1 John 4:8, "God is love." Making connects knowing with our acts of love, and with the greater reality behind materials and the body. Jacques Pépin's omelettes are better than mine because of his taste of a lifetime of knowing and loving the omelette-making process.

Saint Paul writes in 1 Corinthians 13, in the famous "love" passage: "If I speak in the tongues of men or of angels, but do not have love, I am only a resounding gong or a clanging cymbal. If I have the gift of prophecy and can fathom all mysteries and all knowledge, and if I have a faith that can move mountains, but do not have love, I am nothing" (vv. 1–2).

If "to love will be to know," then our knowledge of God depends upon the act of making. To build on Meek's statement, to make (in loving attention) will be to know. Of course, that making is effective only if we create into what is good, true, and beautiful—what God initiated in Genesis 1. Pépin can make what I cannot. By that definition he "knows" how to make an omelette, and I do not. That simply means that I have not loved deeply enough.

The corollary is also true: Unless there is tangible, fruitful reality that is made into the world, what we know, and what we preach, has not incarnated itself fully in love. No matter how high the ideal, or how great the preaching, the true test of the power of the gospel to affect our lives is in the "bottom line" of what we have created into the world through love. The first question that should be asked as people walk into our church buildings is, "What did you make this week?" Instead, we have many "recipes" for theology and churches, and we tend to argue over whose recipe is best. We need to judge on the basis of the fruit of making and let that be the pathway to God.[2]

Modern theology has much to say—those many "recipes"—about how to understand concepts such as incarnation and salvation. But that alone does not actually make the omelette; it does not make theology incarnate into our reality. Here's where an artist can help. Makers are

experienced at navigating the gap between ideas and reality. Makers can help us to love more deeply.

UNICORN TAPESTRIES

My eldest son grew up in an environment of creativity and the arts. Having an artist for a father in New York City, he very quickly reached a saturation level in attending openings and cultural events. By the time my two boys were thirteen years old they were rolling their eyes when I asked them whether they wanted to go to a gallery or a museum.

But my eldest began to date a girl he met on a missions trip to Juarez, Mexico. So I asked him where he might consider taking her. He replied, "Oh, the Cloisters, of course."

The Cloisters is one of my favorite places to go. Located at the northern end of New York City, this extension of the Metropolitan Museum of Art dedicated to medieval art has been my inspiration, from its quince trees in the medieval courtyard overlooking the Hudson River to its famed unicorn tapestries. So I asked my son what he was going to show her.

"Oh, the unicorn tapestries, of course."

Apparently, my son was listening to me when I took him there as a boy, though at the time he seemed to want to throw a baseball rather than listen to my lectures on the significance of the unicorn tapestries. Now he is married to that young girl, and they have two children. I am grateful for the unicorn tapestries.

Love demands creativity; love draws out our call to make. Love is the language of the Holy Spirit; and through love, the Spirit guides us.

If you are dating someone, that love will translate into creativity and beauty. If you love someone, it is inconceivable to not be imaginative and creative. When I speak to teenagers (especially at boys' schools), I tell them that they need to know art history, music theory, and cinema

studies just to be better at dating! (I get their attention right away when I share this.) The beauty of art, music, dance, and theater (let alone architecture, poetry, stories, and gardening) invokes the God of Creation, the Spirit of mediation into the heart of love.

This is the work of Making.

REDEFINING WORK

I'd like to retrace briefly what work meant in Eden. The Bible tells us in Genesis that some materials were hidden beneath the ground outside of Eden: "A river watering the garden flowed from Eden; from there it was separated into four headwaters. The name of the first is the Pishon; it winds through the entire land of Havilah, where there is gold" (Genesis 2:10–11). Why would this passage be in Genesis? Was there an anticipation that the narrator of Genesis wanted the audience to understand? It may be that Adam and Eve were to eventually find the materials and build something outside of Eden. Build what? If there was not yet any need for them to protect themselves or shelter themselves in this time before the curses of the Fall, then what was there to build? That certainly takes imagination. But the very fact that such a passage is recorded in the Bible is a window into the mysteries of God's Creation, and of our journeys. Further, it affirms the reality of the need for imagination before the Fall—to imagine the future and create toward it. Logic will lead us to conclude that even in a sinless world, imagination, which Adam exercised when he named the animals, existed then and exists now to forge the future—and continual creativity will be at work in the coming world. Before the Fall, we were all artists and poets.

Let's think a bit more about the notion that God does not need us to do anything. God's Creation is a gratuitous exercise of love. We know that God rested on the seventh day; it follows that God worked on the

others. Then God, who makes humans in God's image, expected Adam and Eve to do the same: to create out of their love of Eden. Whatever Adam and Eve would have created, it would not have been to fix the world, which did not yet need fixing, but to make a gratuitous gesture of love. Even after the Fall, work was not cursed but was a way to make toward the New Creation.

Of course, the problem for us is that because of the Fall, the path back to Eden is blocked. Now, our imagination is distorted; we are unable to truly imagine, and we cannot see God face to face. The Genesis account tells us that the entry to Eden is guarded by cherubim: "After he drove the man out, he placed on the east side of the Garden of Eden cherubim and a flaming sword flashing back and forth to guard the way to the tree of life" (Genesis 3:24). Some may assume that the work that Jesus has done on the cross will restore us fully to Eden and the tree of life. Some may preach that all the blessing and protection of Eden will be bestowed upon Christians and that Christians therefore will be prosperous and without the curse of sin. This view does not align with the scriptures written after the resurrection of Jesus. Instead, the epistles implore us to endure persecution and suffering: "Dear friends, do not be surprised at the fiery ordeal that has come on you to test you, as though something strange were happening to you. But rejoice inasmuch as you participate in the sufferings of Christ, so that you may be overjoyed when his glory is revealed. If you are insulted because of the name of Christ, you are blessed, for the Spirit of glory and of God rests on you" (1 Peter 4:12–14).

In reading the epistles, we find more Christians suffering because of their faith than being prosperous and happy because of it. Christians' happiness is quite different from the world's. Jesus promised us an abundant life, but not an easy one (John 10:10). It is through the threads of suffering, persecution, and life's difficulties that God weaves a tapestry of hope toward the New. Just like the art of Kintsugi, what once was

broken is repaired not to hide its flaws but to celebrate them as part of what is to become beautiful.

To be an artist is to redefine, in some way, what work is. We often consider work to be cursed because of the Fall, but in the biblical sense, work itself is not cursed, only the serpent and the ground are cursed (Genesis 3:14, 17). The biblical notion of work reflected in the Hebrew word *avodah* connects blessings with work.[3] We can think of stewardship before the Fall, such as Adam's naming of the animals, as both work and art. Edenic memory can provide a unique framework and a paradigm for human thriving connected with work east of Eden. Perhaps uniquely, art points to the gift of work. In the words of Aristotle, which are well worth repeating, "Art is our capacity to make."

THE GIFT ECONOMY:
ART'S AND LEISURE'S PATHS TOWARD THRIVING

In his remarkably prescient book *The Gift*, from 1983, the poet Lewis Hyde links thoughts about work and rampant commoditization that work against artistic and human thriving. He writes in the introduction: "It is the assumption of this book that a work of art is a gift, not a commodity. Or, to state the modern case with more precision, that works of art exist simultaneously in two 'economies,' a market economy and a gift economy. Only one of these is essential, however: a work of art can survive without the market, but where there is no gift, there is no art."[4]

Art is part of our work (therefore "work of art"), yet art must be treated as a gift, not merely a commodity. Art needs to back into the pristine river of the gift economy. Work is redefined here as the central gift of art; to Hyde, without such a gift, there would be no art or thriving market.[5]

But given the current conditions of the river of culture, the arts will

always be impoverished. The river of culture has led to a dehumanized view of art, its beauty robbed by overcommoditization. Thus, rebuilding a vigorous ecosystem of art depends on the existence, and the recognition, of the principle that "where there is no gift, there is no art." Where there is no gift, there is not likely to be a pristine river, either. Therefore, although nature and art can exist in the absence of market economies, one should argue for the corollary: a truly humanized market economy cannot exist unless a pristine river of creativity runs through the heart of our cities.

Hyde identifies the blind spot of modern economics and provides an alternative; he presents a hybrid model combining elements of market economies with his framework for a gift economy that would take into account creativity, the arts, and sustainability. He proposes inventive ways to share creative gifts, such as creative commons and agreements for open sourcing of creative gifts.

For me, reading Hyde's book for the first time was like walking into the wardrobe that leads to Narnia. Hyde's words reverberate into the enchanted heart of culture making, and the Good News presented in the Bible. Hyde writes: "A gift may be the actual agent of change, the bearer of new life. In the simplest examples, gifts carry an identity with them, and to accept the gift amounts to incorporating the new identity. It is as if such a gift passes through the body and leaves us altered. The gift is not merely the witness or guardian to new life, but the creator."[6]

Though Hyde does not go so far as to say this, the gift of God, "the bearer of new life," is Christ, whom the New Testament calls not only the Savior, but also the Creator (Colossians 1:16).[7] Christ is an example of a pure gift, and he is the Gift. During communion, the Gift literally passes through our bodies and leaves us altered (or altared, if you will)—both transforming us and sanctifying us. There is no reciprocity in this transaction: God likes to give one-way gifts that cannot be reciprocated. We cannot outgive or outgift God.

And yet in our churches, we have often treated the gospel like a commodity, shopping it around as if we were peddlers or, worse yet, savvy performers. When our churches look like gigantic malls, hotels, or even strip malls, and when we proclaim "salvation comes free, at no cost," we are unwittingly falling in with the architecture and the language of a transactional consumer economy. Of course, informed decision-making needs to be part of the transaction, and we must have a convenient location to meet for worship. But the context and method for sharing the Good News tap too often into the consumer mentality.

Yes, you might argue, but if that method works, and the Good News is preached, what's wrong with that?

What's wrong is that churches are not investing enough time and effort in thinking about the context of communication, and they are not empowering makers. We often seek out experienced business minds to lead our church financial drives, but churches rarely seek out artists who exemplify "the gift economy" to help lead in creating the context for their communication. And if we do not consider the context, the context will define our message as much as our preaching and singing do. The Theology of Making encourages churches to prioritize the gift economy, to restore our message as a powerful antidote to greed, thereby freeing culture from its "bondage to decay" (Romans 8:21).

Hyde warns that "just as gifts are linked to the death that moves toward new life, so, for those who believe in transformation (either in this life or in another), ideologies of market exchange have become associated with the death that goes nowhere." He notes that George Romero, who made the horror film *The Dawn of the Dead*, set the film in a shopping mall in Pittsburgh where "the restless dead of a commodity civilization will tread out their numberless days."[8] We apparently have a culture in which the Good News and horror stories are broadcast in similar packages.

It's no wonder that the culture is confused as to what churches are meant to represent.

But the gospel is the greatest of the Gift of Christ, and a true gift, by definition, cannot be bought or sold but can only be passed on—possibly at great sacrifice. The problem is that our consumer mindset is in play whether we accept the gift or reject it. If we accept the gospel, we tend to think of our decision as bartering with God, saying something like, *God, if you can get me out of this mess, I'll believe in you and be good for the rest of my life*—which at root means, *What am I supposed to get in this transaction? What am I entitled to?* This reasoning is our consumer, transactional language—that we can somehow persuade God to buy our goods; it is our effort to redeem ourselves and not to have faith, learning to depend on God.

But more profoundly troubling is the possibility that the listeners of such a false gospel reject the true gift of the gospel with a consumer mindset. The rejection is our free choice, like saying "no" to a vacuum cleaner salesperson (or now an Instagram ad), but we reject the gospel without realizing what we are doing. If the gospel is the only true gift that leads to life, then rejecting it is not simply a transaction, but a deeper offense—and ultimately a rejection of our destiny into abundance and thriving. In some cultures, a child's rejection of a gift given by a parent is paramount to rejecting the parent. In the famed story of the Prodigal Son, that was precisely the situation. The younger son not only rejected his inheritance; but by his actions, he told his father, "I want you dead."[9] If we refuse to accept God's gift, then we are not just rejecting a vacuum cleaner that is advertised as guaranteed to clean our hearts of sin; we are rejecting the Father love of God.

The greatest miracle of the resurrection of Christ is not just the body of Jesus taking on a new, multidimensional, transformed DNA; the greatest miracle is the fact that the miracle itself reveals the expansiveness of God and the potential for a greater and deeper miracle that surpasses our imaginative capacities. By definition, God's miracle breaks nature wide open, and such an act is the ultimate transgression in love by God toward

God's own Creation. The true gift, if fully understood and embraced, will transform us from within and make us beings of hope.

I recently reread the famous passage in the book of Isaiah that anticipates the coming of Emmanuel: "For to us a child is born, / to us a son is given, / and the government will be on his shoulders" (Isaiah 9:6). We need to realize the context in which this prophecy was given: Isaiah's startling vision came during a conflict like the one now in Gaza, and it warned of escalating conflicts and of bloodshed on both sides. Back then, strikes and skirmishes were threatening the destruction of nations and citizens alike. In short, nothing much has changed; we just have bigger weapons. The promise of the Gift, who will rule with justice and peace, could not have come at a more crucial time. But often, such prophecy is seen as a fantasy of sorts when everyday life is under threat and peace seems impossible to attain. When such a powerful prophecy is commoditized as Christmas trinkets or as sentimental ideas of peace, we lose the power of these words given into the heart of the impossible conflicts of our times.

In Hyde's conclusion, he writes that "there are limits to the power of the will. The will knows about survival and endurance; it can direct attention and energy; it can finish things. But we cannot remember a tune or a dream on willpower. . . . The will by itself cannot heal the soul. And it cannot create."[10] The will to fix the world inspired by our plumbing theology will fall short of our goal to create a movement of the gospel. Instead, the church must begin to create an alternate gift economy, a generous river of creativity flowing out of the cities, a river full of gems of art and nature. This must be accompanied by a hybrid economy that combines capitalistic society with creative society, and considers and values things beyond survival, endurance, and transactional benefits.

The Catholic philosopher Jacques Maritain observes that Thomas Aquinas identified two paths to knowledge: one, Maritain notes, is "moral science, the conceptual and rational knowledge of virtues." The

other is knowledge by "connaturality," such that "we can possess the virtue in question in our own powers of will and desire," have it "embodied in ourselves, and thus be in accordance with it or connatured with it in our very being." This second way of knowledge, Maritain continues, is "not rational knowledge, knowledge through the conceptual, logical, and discursive exercise of reason. But it is really and genuinely knowledge." This "connatured" knowledge is what artistic, somatic knowledge can provide us:

> Knowledge through connaturality plays an immense part
> in human life. Modern philosophers have thrown it into
> oblivion, but the ancient Doctors [of the church] paid careful
> attention to it and established upon it all their theory of God-
> given contemplation. I think that we have to restore it, and
> to recognize its basic role and importance in such domains
> as moral practical knowledge and natural or supernatural
> mystical experience—and in the domain of art and poetry.[11]

This "knowledge through connaturality" is an integrated knowledge that one can only gain through the years of practice of creative making. This book, in that sense, flows out of my daily practice in the studio, reflecting on the Word of God, and then the "knowledge" of what I am writing is filtered up through the act of making. Maritain argues that such knowledge is not separated from reason, but this deeper knowledge of the imagination is the basis of all knowledge. In other words, artists provide the deepest realm of knowing that is given to artists to cultivate. The current reality of artists being disconnected from other disciplines, and even, in some cases, being seen as opposed to reason, creates a false dichotomy of knowing. Art is fundamental to the human search for deeper understanding. Art, by extension of this reasoning, is fundamental to understanding the Bible.

The *poieo* and *poietes* reality of the Bible undergirds our poetic, somatic journey into the Theology of Making.[12] The true and lasting understanding of the gospel is not whether we can recite our creeds, or even are able to convey the information of the gospel to others; the ultimate understanding of the gospel is what we make, and what we love, with what we know, or that deepest realm of knowledge that is garnered through our making. This is the deepest cultivation of the soil of our minds and culture. This is the path to be "filled with the Spirit," with the fruit of the Spirit being "love, joy, peace, forbearance, kindness, goodness, faithfulness, gentleness and self-control. Against such things there is no law" (Galatians 5:22–23). Such fruit, filled with love, is incarnated into what we make, thus creating cultivated movement into culture at large.

Cultivation to grow crops and making and natural realities are connected at a deeper level, just as my use of minerals from the earth creates my paint and transforms the process into the layers of work. These layers are also a metaphor of my life. I "consider the lilies" by growing them, and then painting them as an artist by "considering" the materials I use. The paper I use is cultivated by the hands of Japanese papermakers who "consider" mulberry bushes in such a way as to make a particular paper that I am looking for. The brushes I use are made so that I can use gold powder mixed with *nikawa* glue, and the lines come out precisely in the flow that only that brush can make on that particular mulberry paper.

Just as it took generations of committed Japanese craft folks to develop the finest of papers (sadly, now disappearing), it will take generations of committed craft folks of culture care to incarnate the fruit of the Spirit into culture. Theology, too, must be thought of as an organic layer of growth, rather than as a mechanistic, rational argument only. Theology must grow and be sown into the soils of culture, be fed by spring rains of love to be cultivated into multiple generations.

EUCHARIST:
CONNECTING US AS MAKERS TO THE MAKER

This type of specificity in creating—not just "using" materials but collaborating with other makers to make my making possible—is precisely what the biblical culture suggests. Consider the Christian Eucharist. The Eucharist assumes that we make with our own hands the very elements that will symbolize the broken body of Christ and the redemptive sacrifice that leads us to the New Creation. We use the bread and wine to represent what is to come (I believe that in such use, the elements are not just symbols, but are actual parts of the New Creation).[13] Such is the "connaturality" of the gospel played into the most sacred act of any Sunday worship. Such making requires the collaboration of farmers, perhaps for generations, who raise wheat, bread makers who bake the bread, and the bread shop that distributes it. The Eucharist is the fundamental paradigm for biblical faith, and it is fundamental to Making toward the New.

The Eucharist relies on us to be culture makers.[14] Bread and wine are both realities that would not exist on their own, but earthly materials must be cultivated by human beings and require much time to create. In other words, just by wheat or grapes growing naturally, neither of these elements for the Eucharist will be created. Human beings, through their toil, and over a period of time experimenting to perfect the craft, have made bread and wine.

This reality opens up the thesis of this book: God, for some mysterious reason, waits upon human making and chose to use our ability to make bread and wine to reveal Jesus's resurrected presence known at the table of the Eucharist. Imagine that! The resurrected Christ waits until we create, until the soil we cultivate is harvested, and until we make, to reveal himself to us!

The making of both bread and wine cannot be done casually or without much training. These are two abilities that may require Malcolm Gladwell's "10,000-Hour Rule" to master at their highest levels.[15] Indeed, if one is to prepare bread and wine for God's feast, one better be the best at it. I realize that there is a level of institutional comfort involved in a consecrated bread and wine that are "sanctioned." But no matter what we choose to be sacramental, the idea here is to posit that God waits for us.

The Eucharist is a critical element in bridging the Creation and is a redemptive element that acts as a bridge to the New Creation narrative. No matter how we view the reality of God's presence at the table, whether as symbol or as the reality of Christ's body, the Eucharist opens the path for the Theology of Making. Pauline language here suggests that the powerful new reality breaks as a new paradigm for the old earth, as this New Creation (Greek *kainos ktisis*), as if the new heaven and new earth promised in the days to come break into our domain in God's time, heaven breaking into, and pouring gold into, our fractured earth. The resurrected presence of Christ, therefore the New Creation, is already at hand when we receive the Eucharist.

At this feast of the Eucharist, this reality is at least partially present in the presence of Christ, and such a journey necessarily includes the broken body and poured sacrifice of Christ. This central act of worship at the table echoes the sacrifice made in the tabernacle of ancient Israel, in the making of the Ark of the Covenant and the mercy seat that sits atop it, upon which the high priest sprinkled the blood of a sacrifice. These typologies foreshadow Christ's sacrifice, connecting the act of Making by human hands and cultural knowledge to the greater call to worship the living God.

6

Seeing the Future with the Eyes of the Heart

In my recent exhibit in New York, I exhibited a triptych spanning more than thirty-three feet called *Sea Beyond*.[1] The title came about when I was commissioned to create a new set of prints at Lichtenstein Studios six months before the exhibit was conceived. We had pulled a print that seems to capture the New Creation, and I coined the print a "Sea Beyond" print.[2]

I thought about how I might expand this vision and decided to paint a monumental piece in my studio in Pasadena that winter. I had been inspired by the sea horizons of the Newport Beach area where my daughter resided at the time. I decided to severely restrict the materials—to only one—the oyster *gofun* materials of ancient Japan.

The gofun technique is one of the hardest to master. It requires pulverizing oyster shells into a fine powder and then mixing that powder into a glue using a mortar and pestle. The resulting white mixture has one of the most magical, unique qualities of white. Depending on the treatment, the artist can control the opacity and transparency at the same time. In other words, one can paint a whole spectrum of "colors" using one material.

The *Sea Beyond* triptych has more than a hundred layers, but in order to appreciate that, the viewer needs to slow down, as our eyes are driven to make quick interpretations. The layers are done with semitransparent layering, so during the initial glance, one would not see the layers. I was 80 percent done with the layering when I found myself in Newport Beach, having been invited by dear friends and collectors to spend time at this beautiful site.

That was when I received a call from my brother notifying me that my mother had passed away suddenly in Los Gatos, California, where for many years she had been suffering from dementia. Every time I visited her, I could see that her memory was fading away, so it always felt like I was saying my final good-bye to her when I left. But physically she had been doing well, so we were surprised that God had taken her, out of mercy, that evening.

I went to the beach to pray, looking out at the horizon. And it occurred to me to ask, "What is beyond the horizon?" I meant not figuratively, but literally. When I Googled this question, I was astonished to discover that from where I stood, I was looking directly at Kamakura, Japan.

When I was a child, my mother often took me to the coves of Kamakura to watch fishermen bring in their morning catch and to enjoy the summer pyrotechnical abstraction of fireworks in the sky. There is a public pool by the cove where I swam almost every day in the summers. There are hidden caves in the peninsula where I used to hide and make art with seashells and sand. All of those memories came flooding back, and I was overwhelmed with emotion as I watched the dolphins arc near the horizon at Newport Beach.

It became clear to me then that, as usual, my intuition was way ahead of me. I had been painting an elegy to my mother even before she had passed. The sea horizon not only pointed to *Sea Beyond*, but my mother would meet me on the other side in eternity, at Kamakura beach. An art-

ist's intuition taps into New Creation this way. An artist, simply by being honest to the sense of the world, can tap into future realities.

THE FUTURE IS NOT GOING UP IN FLAMES

I recently heard a pastor say, "There are only two things that last eternally: God's Word and people. Everything else is going to burn up." Biblical passages disagree (1 Corinthians 3, for instance; discussed further on pages 126–129). The Bible does speak of fire, but it is a sanctifying fire. As N. T. Wright notes, there is a profound connection between this world and heavenly reality. In the Lord's Prayer, after all, we pray "Thy Kingdom come on this earth as well as in heaven." We are not praying "Thy Kingdom come, please burn up this earth." Think of God's Kingdom coming as a heavenly invasion into the ordinary, an infinite abundance injected into our scarcity-marked world. The Lord's Prayer reminds us that the generative power of Genesis and the New Creation is transforming us, transfiguring us on this side of eternity to prepare us for our role as "co-heirs" with Christ (Romans 8:17). Creating a false dichotomy of earth (leading to hell) and heaven would be an easy way to justify a Christian's purposeful existence, but doing this would deny the very promise and power of the Lord's Prayer. We do not go to heaven after we die to play a harp on silver clouds (although it is not incorrect to use that metaphor of "heaven"). The Good News is that heaven will come to us to resurrect our decaying bodies and earth, too, in mysterious ways, such that we will hear amplified and transfigured versions of the music we have composed, or we will be able to marvel at the vista, even an entire Kingdom, created on the basis of the landscape we have painted. In my case, such a world will amplify the materiality of the silvers I use on my "cloud skin" Japanese paper.[3]

A friend who was sitting with me also heard this comment by the

pastor and later remarked, "That's not a Theology of Making . . . that's a theology of evaporation." Another pastor-leader chimed in, "No, that's a theology of extinction." As discussed earlier, I call this symptom plumbing theology, a term that sums up the utilitarian character of an all-too-common reductivism among preachers and teachers. Such teachings stem from false dichotomies and reduce the gospel to either evaporation or, worse yet, cultural extinction. If God is the Artist, God does not create to make things disappear. It is in the very nature of God to create for an enduring future. The Bible is not about the End; it is about the New. The fire of judgment melts away dross, but ultimately it is a sanctifying fire.

A Theology of New Creation may at first seem "too good to be true": excessively generous, even gratuitous. This generative path challenges our obsession to reduce everything to utilitarian pragmatism and presuppose a scarcity model. But there is not an iota of scarcity in "In the beginning, God created the heavens and the earth." The God of the Bible is the God of abundance. Therefore, Jesus's preaching addresses the mindsets of scarcity-ridden, fear-filled followers. "Consider the lilies," "love your enemies," "blessed are the poor," the many parables that assume abundance at the core of our lives—they all point to the greater love. Love demands more than utility; a greater love expands purposefully into an expansive and enduring realm of relational depth. When we say God is purposeful, we need to move beyond our industrial mindset of bottom-line thinking about efficiency and success. God is gratuitously purposeful to bring vast, abundant beauty into our lives.

God's purposefulness is not aligned with our notion of day-to-day pragmatic purpose. God did not build us as survival machines that would function like clockwork; we are creatures of magnificence and imagination, made in the image of God. We are not like horses that are being trained to jump higher and higher, or to do useful things such as pull a heavier load. Instead, we are, as C. S. Lewis puts it, horses that have

grown wings. We do not need to be trained to jump higher and higher to move along our trajectory of morality; we need to learn to use our wings to reach an altitude with a greater vista of Making. Lewis writes in *Mere Christianity:*

> God became man to turn creatures into sons: not simply to produce better men of the old kind but to produce a new kind of man. It is not like teaching a horse to jump better and better but like turning a horse into a winged creature. Of course, once it has got its wings, it will soar over fences which could never have been jumped and thus beat the natural horse at its own game. But there may be a period, while the wings are just beginning to grow, when it cannot do so: and at that stage the lumps on the shoulders—no one could tell by looking at them that they are going to be wings—may even give it an awkward appearance.[4]

Christians are "horses with wings"; yet our preaching and teaching tend to encourage us to jump higher and higher, rather than to risk using our wings. Lewis is right; wings, yet unformed, do look awkward, and yet the way to grow them is to actually dare to use them. Of course, as many artists know, it requires many years of failing to grow wings. A church should be a place of nurturing those wings, a context and environment for failing many, many times rather than demanding that believers jump higher and higher in the art of moralism.

Any type of Making will certainly demand gratuity and excess. We are lovingly growing wings toward the New Creation. If you love, you are in the "making mode," and before long, love moves beyond the mechanism of survival, especially, as I've noted, if you are dating someone. Love moves us to give attention to a specific person. The Bible is God's love letter, beckoning to a future Bride to have faith in the Bridegroom. Genesis

is God's love poem, sung over us in Creation, now marred with scarcity and the necessity to survive, and that song still resounds over each of us throughout the Bible. As a love poem, God's voice of Creation can open the heart of each one of us, to respond differently. As God's Creation is sumptuous and excessive, so must our responses be.

The Bible begins with the Creator creating the world; then it moves to the Edenic mark of God's image of Adam and Eve being commissioned to create. Adam's first recorded words are poetry (Genesis 2:18–23) in response to God's parading every animal in Creation in front of him, and Adam finding that there is no suitable mate for him. Before the Fall there were gold and precious minerals hidden beneath the ground (Genesis 2:11–12), and the biblical narrative specifically links the reality of those materials with stewardship. These materials, I conjecture, were beneath the ground to be discovered by Adam and Eve or by their descendants for the construction of what would become the city of God. Even though that impulse was twisted by the Fall, God continues to mark humanity with the creation of God's communication path through worship—in Solomon's Temple (created by artisans trained in Egypt), then in the creation of the Second Temple, and ultimately pointing to the "unmade" tabernacle of Christ, whose death caused the tearing of the curtains of the Temple to inaugurate a new era.[5] Through Pentecost, the church is filled with the creative, wildly communicative Spirit, and the church body figuratively becomes part of Christ's Temple. Even the "end" of time will be a new beginning toward what this New Creation will become. As theologian Jürgen Moltmann has noted, the Bible is not a book about endings but speaks loudly of new beginnings.[6]

"The presence of God within the creation, as the one whose speaking is the origin of the creation, sets the parameters for a distinctively Christian understanding of language, world and sign," theologian Oliver Davies writes in his remarkable analysis of Creation and God.[7] Art we create out of "language, world and sign" co-authors with this God "within the

creation" into the New Creation to come. Yet, our delivery of such Good News is truncated by our notion of the limitedness of the divine mission.

THE MYSTERY AND BEAUTY BEYOND OUR GRASP

Philosopher Daniel N. Robinson has connected the technological knowledge base that accompanied the NASA space program that put humans on the moon and the affective description that accompanied the experience. The NASA program represents one of the highest levels of the accomplishment of technology, and it resonates with what Robinson calls the "issues of veracity and credulity" that lead one to a "belief in reason."[8] In other words, when we see the success of NASA space missions, we come to have "faith" in scientific and technological progress based on observable sets of data and the human capacity to create based on reason.

In recent times, this type of rational knowledge is often seen as the highest form of accomplishment. Yet even the NASA program shares the element that Jacques Pépin's simple omelette test brings out: a sense of beauty (or taste) must be part of any pursuit.

Astronaut Neil Armstrong experienced this as he walked on the moon: "Yes, the surface is fine and powdery." Gazing at the flat horizon, he took in the view. "Isn't that something! Magnificent sight out here." After collecting a contingency sample, Armstrong looked around and observed, "It has a stark beauty all its own. It's like much of the high desert of the United States. It's different, but it's very pretty out here."

Notice the phrases Armstrong used to describe his experience: "magnificent sight," "stark beauty." He used a simile—"like much of the high desert of the United States." Even at the pinnacle of technological accomplishment, this engineer used subjective, affective language. If on that day in 1969 the news reports had simply told us "a man landed on the moon," would we remember it as well? Would it have affected us as

deeply as the language that allows us to "land on the moon," too, in our imaginations? We are poetic beings, whether on Earth or on the moon. The language of beauty and majesty draws us into the mysterious realm, causing us to wonder about and dream of the future.

Why do we seek, or need, beauty? Robinson alludes to several philosophic traditions of knowledge, and a religious sense of knowledge ultimately addressing the issue of beauty as part of our necessary journey into a greater knowing. "Though beautiful things cannot be thought worth producing except as possible objects of contemplation," he writes, "still a man may devote himself to their production without any consideration of the persons who are to contemplate them. Similarly knowledge is a good which cannot exist except in minds; and yet one may be more interested in the development of knowledge than in its possession by any particular minds; and may take the former as an ultimate end without regarding the latter."[9] Robinson's argument depends upon another philosopher, G. E. Moore, who wrote that "human beings live and swim in metaphors and allusion to beauty. . . . Supposing no greater good were at all attainable; then beauty must in itself be regarded as a greater good than ugliness."[10]

If we could choose between a purely utilitarian (or "ugly") environment or a beautiful environment that still works well, we would choose a beautiful one. That impulse is not a false, irrational perspective, as some rationalists have argued; this impulse for beauty and the tendency to regard the world with awe are fundamental to our being, made as we are in the image of God.

God is not just the source of beauty; God IS beauty.[11] Genesis 1 speaks of God standing outside of time and space, requiring no preexisting material resources. What we read translated as "God created" is from the Hebrew word *bara,* which connotes a categorically different way of creating from what we are used to: creation *ex nihilo* (out of nothing). If beauty, truth, and goodness are qualities of our movement back to God,

then the end of the rainbow of such a pursuit is not rational recognition, but an encounter. Artists do not seek proof of God's existence; artists explore the unknown in search of deeper meaning. The mystery of God opens up to those who create, and we are brought into the *bara* of Creation. Modernist assumptions that verifiable knowledge is the ultimate path to truth have overlooked the fact that mystery and beauty are at the core of knowing. This book is an effort to affirm such journeys into the unknown, and to provide language and a map.

THE END IS A NEW BEGINNING

Hebrews 11:1 states that "faith is the substance [Greek *hypostasis*] of things hoped for, the evidence of things not seen" (KJV).

Faith, in this way toward hope, trains our imagination to seek out "evidence of things not seen." We stand under hope, as suggested by the Greek *hypostasis*. But our understanding of the gospel, especially in today's consumer culture, seems to "over-stand," forcing the reductive dichotomies driven by fear, as in the choice between heaven and hell, limiting the generative possibilities of what heavenly perspective gives, even in the hellish realities of our days. This reductivism is evident in some Christian market-driven "End Times" prophecies. Such books and movies can sell, as the fear reflected in them captures our ears. In other words, Christian imagination today obsesses over the End rather than scanning for the New Creation in our midst. But we have to ask: Is this fear-driven mentality really biblical?

Jürgen Moltmann writes of the "apocalyptic fantasy" that some Christians have embraced:

Some people think that the Bible has to do with the terrors of the apocalypse, and that the apocalypse is "the end of

the world." The end, they believe, will see the divine "final solution" of all the unsolved problems in personal life, in world history, and in the cosmos. Apocalyptic fantasy has always painted God's great final Judgement on the Last Day with flaming passion: the good people will go to heaven, the wicked will go to hell, and the world will be annihilated in a storm of fire. . . .

These images are apocalyptic, but are they also Christian? No, they are not; for Christian expectation of the future has nothing whatsoever to do with the end, whether it be the end of this life, the end of history, or the end of the world. Christian expectation is about the beginning: the beginning of true life, the beginning of God's kingdom, and the beginning of the new creation of all things into their enduring form. The ancient wisdom of hope says: "The last things are as the first." So God's great promise in the last book of the Bible, the book of Revelation, is: "Behold, I make all things new" (21.5). In the light of this ultimate horizon we read the Bible as the book of God's promises and the hopes of men and women—indeed the hopes of everything created; and from the remembrances of their future we find energies for the new beginning.[12]

Such an apocalyptic fantasy is an idolatrous use of the imagination and works to undermine and even oppose the imaginative act of dreaming for and with God. Such a dream, as Dr. Martin Luther King, Jr., reminded us, is a proper and necessary condition for hope. Our ability to dream, to envision the future in which justice reigns, is one of the great gifts of God to us. And as we are made in the image of God, we are capable of this kind of dreaming. Fantasy is an escape from reality and therefore erodes true hope; but Godly imagination to dream is a coura-

geous journey into the heart of darkness, into the imprisoned realms of our world, that can liberate us from our "bondage to decay and . . . into the freedom and glory of the children of God" (Romans 8:21).

Ellen Davis noted in a recent lecture:

> Idolatry in every form is a distortion of the imagination, for it is through our imagination that God reaches us. When I say "imagination," I don't mean indulgence in fantasies. I mean the mental and spiritual capacity that the biblical writers call the "heart" (Gk: kapoia), the organ that alerts us to what God is doing in our lives or the world. If our spiritual arteries get clogged, cluttered with self-absorption and trivial concerns, then the Holy Spirit cannot reach us, or reach other people through us.[13]

To see with the "eyes of our hearts" (Ephesians 1:18) would be the goal of an imaginative journey and training, and the arts provide a perfect vehicle through which we can move past clogged, cluttered self-absorption into the reliable communal body to experience the Spirit's leading. As my colleague William Dyrness has noted, "Artists, after all, think with their hands and their fingertips, with their eyes and their ears, usually in ways they cannot articulate in words."[14] Such somatic knowledge can lead a whole community to experience God in deeper, fuller ways, speaking into all the senses and gifts of the congregation.

God is ontologically and theologically the center of all things; therefore, we do not have to defend the center. No debate between a theist and a new atheist is going to change the center. The more that theists put themselves on the stage to defend God's existence, the more we fall into a false dichotomy that assumes God can exist or not, depending on our mindset. If God is the center, then that act in itself has no consequence in proving or disproving that existence. Instead of debating, Christians

ought to be involved in Making. That experience is not to "prove" God's existence, but to affirm the source of creativity and imagination, thereby affirming the center. We then focus on what it means to become creatures of the New.

Art should capture the *hypostasis* or "the substance of things hoped" that the writer of Hebrews speaks of, to serve our culture to reveal the "evidence of things not seen." As the Kintsugi metaphor conveys, on this side of eternity it is important for us to see even the end as a new beginning. Such generative thinking trains our hearts to see. Rather than spending all our time coming up with arguments to prove the enemies of our faith to be wrong, we should cultivate awareness of the Spirit, a discipline that leads us to create.

7

Imagination and Faith

As an artist caring for culture, I must ask very simple but expansive questions into the act of making. "What if," I ask in this book, "imagination is seen as necessary, and central, even a requirement for our faith journeys? What if what is central to God's reality is not the mechanistic, utilitarian survival of species, but the exuberant abundance of Creation and New Creation? What if artists can lead in the way of such training, and artists were seen as invaluable parts of church leadership?" In other words, what we consider to be necessary in the industrial sense, of our bottom-line values of efficiency, utility, and pragmatic survival, may not be, in God's eyes, the most central manifestation of God's love into the world. Perhaps, I ask as an artist, being an artist is not an anomaly to faith, but is central to faith and to the place of the church in the world; and in order to understand the fullness of the grace of God, we all must think, act, and make like an artist. Artists can lead in the rediscovery of the central purpose of our being to make.

"Leadership" can take the form of someone standing up to speak in front of a large audience, but that is not its only form. In their quiet

work in their studios and rehearsal halls, artists indeed lead in training our imaginations and are "in the enterprise of persuasion," to rely on the words of Harvard educator Howard Gardner.[1] Can artists lead us in reconsidering and reframing and developing our moral imaginations?

In my book *Culture Care* I told many stories of bringing readers into a different mindset toward culture and the arts, as an alternative to the mindset we are currently accustomed to in our culture wars. I propose that bringing beauty into a scarcity mindset environment is a far more effective way to create long-term change than the "zero-sum game" of fighting to control limited cultural territories as in the culture wars mindset. We need to be sowing seeds of beauty and tilling the hardened soils of culture even before the long, hard winter sets in. The stories and chapters of this book unfurl theological points that are not explicit in *Culture Care*. I reveal them here because the Theology of Making is the theological undergirding of culture care. Culture care has a broad thesis for the culture at large, both within and outside of the church; the Theology of Making provides the foundation for that thesis by cultivating the knowledge that is rooted in the gospel and exploring what it means for our own education, and our children's.

What have the limited resource battles of the culture wars produced in our culture? As I've noted, the culture wars have resulted in ever-shrinking territories of defending one's ideological turf, no matter which side of the aisle one is on politically. Christians are seen in culture as promoting hatred instead of love, vindictiveness instead of joy, vilification instead of peace, alarmism instead of patience, discord instead of kindness, racism instead of goodness, prosperity instead of faithfulness, and the imposition of power instead of self-control. We need only to look at ourselves in the mirror to see that our witness has not produced the fruit of the Spirit in the culture at large; instead, we have withdrawn into our fear-filled shells. So how we learn, and how we teach, matters to produce the good fruit that God has in store for us. The generational work

of cultivating such fruit will have ramifications not just in the church, but in the wider culture. We need to recall that historically it was often Christians who emphasized the importance of schools and hospitals, becoming generous patrons of education, mercy, and the cultivation of beauty. We must recover our call as makers into culture, positing the fruit of the Spirit as makers into the next generations. Education cultivates imagination as the chief faculties of knowing and Making.

Psychiatrist Curt Thompson told me once that the brain works "bottom to top, and right to left." One way human beings learn, he said, is by applying the experiential, the affective, to rationality ("right brain" to "left brain"—as much as this notion is contested today in scientific circles). We also learn through tacit knowledge gained from our senses and bodies and then integrated into our rational knowledge ("down-up"). He told me that today, in schools and churches, we communicate "left to right, and top to bottom"—the very opposite of the natural, effective paths to "knowing."

Again, this book asks: What if we journeyed into theological thoughts through the act of making, rather than strictly from rational and propositional theological information? What if we understood theology and the Christian gospel through caring for our souls and our environs? Cultivating our imagination is essential to fully realizing our potential as God's creatures. I now dare to go a step further in our understanding of the role of imagination. It is impossible to have faith without imagination. This sounds rather heretical, so let me explain.

In the Bible, we often read metaphorical descriptions or descriptions that rely on simile, such as this one describing the resurrected Jesus: "The hair on his head was white like wool, as white as snow, and his eyes were like blazing fire" (Revelation 1:14). It is impossible not to "see" this through the eyes of imagination. I once heard a comedian say, "Don't imagine a pink elephant!"—but as soon as we hear "pink elephant," our imaginations go to work. Yet many discussions in biblical studies ignore

the role of imagination. Let me push this line of thought a bit further into perhaps one of the most controversial statements ever uttered by a poet.

William Blake once wrote, "A Poet, a Painter, a Musician, an Architect; the man or woman who is not one of these is not a Christian."[2]

How could he say that? What did he mean?

Before I defend Blake's position, let me share a bit of my journey toward this question, a journey that is probably typical of an artist of faith. Early in my walk as a Christian, as I began to share about my journey as an artist—how from very early on, I felt called to create beauty—missionaries and ministers told me, "Well, you have to put Christ first and lay all of your gifts at the altar." Some told me that I must give up my art to serve the Lord. I must tell you that I was perfectly willing to "give up my art." Jesus said, "whoever wants to save their life will lose it, but whoever loses their life for me will find it" (Matthew 16:25). We need to find our art by losing it. But I had one question: "So, what I am experiencing through art is not from God?" Other questions followed: "Is art merely an occupation? Are artists a 'people-group to reach'?"

These conversations left me reluctant, once again, to share the "secret" of my experiences of the intimacy of creation, just as I had felt awkward in middle school about telling others about my artistic experiences. I was afraid to even raise questions (for fear they might sound rude) or to share that art was not a mere occupation to me, but a calling, and the greatest of art is created by laying down all things at the altar of the greatest Artist. In my experience, when we surrender all to the greatest Artist, that Artist fills us with the Spirit and makes us even more creative and aware of the greater reality all about us. By "giving up" our "art," we are, paradoxically, made into true artists of the Kingdom.

This is the paradox Blake was addressing. Unless we become makers in the image of the Maker, we labor in vain. Whether we are plumbers, garbage collectors, taxi drivers, or CEOs, we are called by the Great Artist to co-create. The Artist calls us little-'a' artists to co-create, to share in the

"heavenly breaking in" to the broken earth. In order to be called a Christian, we need to be marked with our capacity to make, and generatively create with, and through, the fruit of the Spirit.

Oliver Davies notes about our imaginative journeys into the New:

> Where the imagination takes purchase, the human self who imagines begins to find himself or herself at home in the world. For the imagination is primarily about envisaging possibilities of new existence or new meaning which are constructed from and remain true to the realities that we already know. Our imaginations take us to new places and situations previously unconceived, but they do so by the disciplined reordering of the sensations, memories and perceptions of what is already familiar to us. Exercising a mode of responsibility before the world as we already conceive it, the imagination can be deeply creative and visionary, bearing comparison with the work of art.[3]

This training, or discipleship, of the imagination begins by training one's senses in ways that artists have developed. Artists can thrive by following the Creator/Savior who is Jesus, showing the path of "envisaging possibilities of new existence or new meaning." What Christians call the gospel is the path of imagination and prayer to "envisaging possibilities of new existence."

I used to think that it was because I am an artist that I read the Bible as a book full of creativity, imagination, and art. I share in this book what I see in these chapters of the Bible. I am now convinced that God is indeed THE Artist (I believe God to be the only true Artist, as I've noted), and this role of God as the Creator/Artist deserves a far more central role in the domain of theology and missions. Therefore, the gospel (as an entire history of God's people) is God's artwork, God's

ultimate story. The faith journey opens the art of the Creator in us, as a gift, and such a gift needs to be honored; therefore, Blake is insistent on focusing on "Christian" as a word that must be directly tied to being a maker.

Now, when I make such pronouncements, I can hear the critiques. "You can't make an exceptionalism for Artists. God loves all occupations." "Blake was a Romantic, and you can't base your theology on a false worldview." "Imagination is dangerous." "We are the people of the 'Word,' and we can't trust images."

I'll take a bit of time here to respond to these critiques.

First, as I've argued elsewhere, an artistic call is not the same as an occupation. Artists dwell in difficult terrain in that not all art and poetry will be valued as commoditized objects, like plumbing is; art is not useful in that sense. So what I mean by "art" does not mean a category of work or occupation in the conventional sense.

We can establish a certain exceptionalism for art, as this book does— a recognition that it does not fit into established categories and norms— but still, our understanding of that exceptionalism depends on what we mean by art. This book is about human imagination that is based on God's imagination and creativity. For God, to imagine is to create. For us, on the other hand, as God's creatures, there is a gap between what we see in faith (imagination) and what we create.

William Blake, in his inimitable way, is saying what the thesis of this book expresses: we are all artists of the Kingdom, and the world needs to see such extravagant beauty in us, or else we are not the Bride of Christ, which is the church.

THE LANGUAGE OF ART
IN A WORLD OF SYSTEMS

For thirty years, I avoided talking about what I see.[4] I now have come to a place of surrender. I must speak of the secret things of the world that I perceive as an artist in order to help the reader see the world as God the Artist intended. Instead of being afraid of being a misfit, or making controversial comments such as those made by poets and artists like Blake, I am determined now to journey into the mysteries of reality. We are all misfits in that sense, created in Christ to have a unique voice in understanding theology and God's love into the margins of our existence.

The Island of Misfit Toys, from the television special *Rudolph the Red-Nosed Reindeer* in 1964, may be a land of last resort, but in magical stories, that part of us which makes us misfits can liberate us. Rudolph's red nose, a kiss of a princess, a Beast who protects the Beauty with his life—they all seem to point to a deeper journey, a deeper well of experience that all of us value and need. We swim in these tales to unlock our journey of imagination, and also to make sense of the world.

At the beginning of the twentieth century, the philosopher William James noted something very important: "Truths emerge from facts, but they dip forward into facts again and add to them; which facts again create or reveal new truth (the word is indifferent) and so on indefinitely."[5] James was affirming a generative path toward knowledge. This is the type of pragmatism that led to advances in the arts and sciences during the twentieth century. It is quite different from utilitarian pragmatism, a dogma that bases all value judgments on one consideration: usefulness. Utilitarian pragmatism overrides the essence of James's more nuanced pragmatism and declares that what is efficient, practical, and useful is to be valued the most. Artists are deemed impractical because they create

things that are not useful, like poetry, dance, and paintings (and paintings that do not have explicit images are especially not useful!).

James dipped into the same river of ideas, but his generative views about knowledge do not seem to be part of the current understanding of the word "pragmatism." Today, pragmatism and practicality are seen strictly from the utilitarian perspective, not from the generative. If God created gratuitously in love, if God does NOT need us, then where does pragmatism fit in?

It could be argued that God created order in the universe because of God's character, particularly God's love of creating. In creativity, one can argue, one needs systems and order. So in a sense, pragmatism is bound up in the order that is embedded in creation, and we can harness it when we value the discovery of such systems. James's point of view was that such inquiry is generative in nature. The sciences in general discover such systems and order. But true pragmatism, defined by James, also assumes the abundance of God's world to sustain us beyond our "usefulness." In order for us to move beyond our utility, we need to stop regarding as the center of our being what we do to be useful and recognize that who we are in relationship to the center, God, is more important.

Initially, the sciences were seen as ways to test the purposefulness of God's Creation and harness it for our use, in order to master the brokenness in the world. The order of Creation can be used to understand the mechanisms of the universe; we can apply that understanding to create knowledge that can master and surpass nature's power and limitations. My father, one of the world's leading acoustics researchers, told me several times that without the Judeo-Christian assumptions of basic unity and order in the universe, it would have been impossible to have what he termed "occidental sciences." My father was not a Christian in the sense most of us define the term, but he believed in the basic unity and logic built into nature.

As Christians, we have a huge advantage. We might go further and

ask ourselves if we can be aware of God's presence in our lives, and give attention to God by probing into God's Creation. Even asking an existential question—does God exist?—is, in itself, an attempt to know how God may be deeply embedded in our thought patterns, and in Creation.

GOD'S INVITATION TO THE WORK OF IMAGINATION

A poet names experiences—life's "minute particulars," as Blake would have it—of the grandeur of the cosmos and, sometimes, even animals. There was also a poet residing in Eden, and his name was Adam. He named animals (Genesis 2:20). Here is his story (Genesis 2:8–25):

Now the LORD God had planted a garden in the east, in Eden; and there he put the man he had formed. And the LORD God made all kinds of trees grow out of the ground—trees that were pleasing to the eye and good for food. In the middle of the garden were the tree of life and the tree of the knowledge of good and evil.

A river watering the garden flowed from Eden; from there it was separated into four headwaters. The name of the first is the Pishon; it winds through the entire land of Havilah, where there is gold. (The gold of that land is good; aromatic resin and onyx are also there.) The name of the second river is the Gihon; it winds through the entire land of Cush. The name of the third river is the Tigris; it runs along the east side of Ashur. And the fourth river is the Euphrates.

The LORD God took the man and put him in the Garden of Eden to work it and take care of it. And the LORD God commanded the man, "You are free to eat from any tree in the garden; but you must not eat from the tree of the knowledge

of good and evil, for when you eat of it you will surely die."

The LORD God said, "It is not good for the man to be alone. I will make a helper suitable for him."

Now the LORD God had formed out of the ground all the beasts of the field and all the birds of the air. He brought them to the man to see what he would name them; and whatever the man called each living creature, that was its name. So the man gave names to all the livestock, the birds of the air and all the beasts of the field.

But for Adam no suitable helper was found. So the LORD God caused the man to fall into a deep sleep; and while he was sleeping, he took one of the man's ribs and closed up the place with flesh. Then the LORD God made a woman from the rib he had taken out of the man, and he brought her to the man.

The man said,

"This is now bone of my bones
 and flesh of my flesh;
she shall be called 'woman,'
 for she was taken out of man."

That is why a man leaves his father and mother and is united to his wife, and they become one flesh.

Adam and his wife were both naked, and they felt no shame.

By asking Adam to name the animals, God commissions him to use his creativity. In this word "commission" we find co-mission, as well; God is inviting Adam to exercise his ability to co-create in Eden. This small gesture, this invitation to co-create, was part of God's design and our mission even before the Fall. Co-creation does not mean that we are equal with God. It's an invitation and recognizes the limitation placed

on Creation and our stewardship as creatures under God's domain. The Creator commissions his creatures to create further by giving Adam a task to "work" the garden (Genesis 2:15). And in this story, this creative act leads to the first marriage, the first wedding.

Here, the Bible tells a story of a union between a man and a woman, a union that will lead in time to a cosmic wedding between Christ and his Bride, the church. The end of that feast will be the true beginning. A wedding will usher in a new age of the Kingdom. As I've noted, many Christians are obsessed with this End. But who ever considers a wedding to be an end of a journey rather than the beginning of one? Again, such a feast is only to mark the beginning of a new age to come. God's purpose in inviting us into co-creation seems to have multiple dimensions. God desires to reveal our need, and to fulfill that need. When we become poets of the Word of God, we discover our true selves hidden in God.

God continually commissions God's children to create. But as all good teachers do, God first creates a context for creativity. God had an educational plan for Adam and so created a "discovery zone" (not a correctional institution!) in Eden. Zones for discovery serve as foundation blocks for a human society to thrive. Our education plan involves all of our senses, our intellect, our emotions, and our empathic capacities, as well as our spiritual capacities. We are to "love the Lord [our] God with all [our] heart and with all [our] soul and with all [our] mind" (Matthew 22:37). We are to multitask, in this sense of using all of our capacities, and "multi-love" all the time.

What was the purpose of Adam's exercise of creativity? Creativity is given to us as a chief means to be caretakers and active stewards of the earth. First, we are to dig deep into the earth to discover good materials: "the gold of that land is good" (Genesis 2:12). Second, we are to be involved in creative work, whether in Eden, or in the world after the Fall, or in the New Kingdom to come. Even in Eden, the gold was hidden.

We have work to do.

Genesis 2:10–14 presumes that Adam's progeny will discover these materials hidden beneath the earth; are we to assume that they would have begun the work of building the city of God in some way, to use the materials, even if the Fall had not occurred? We are to dig beneath the soils of creativity, digging deeper into the experiential realms of art and life for good materials to create with. Part of our stewardship is to till the soil. Are we digging and tilling the soil of culture, the soils of our creativity to build the Kingdom of God? Every farmer knows that the time to work on the soil is when winter approaches. Or in some years, farmers rest the land and let it settle. Either way, a farmer is aware of the need to rejuvenate the land for the spring to come. Unless we diligently prepare the soil for the spring, our effort to sow seeds and cultivate what we desire to cultivate will not bring abundance. In that abundance, there is also freedom.

All art, in some sense, is "naming." In the first human creative act, God gave Adam total freedom to name the animals but with the particular intent to teach Adam his need for Eve. "Whatever the man called each living creature, that was its name" (Genesis 2:19). That's remarkable: Whatever name Adam came up with, God made it permanent. God grants us authority and freedom. God does not micromanage. Jennifer Allen Craft, in *Placemaking and the Arts,* writes this about Genesis 1 and 2:

> While God's activity needs no prerequisite "stuff" or order,
> he does invite his creatures into the responsive process of
> making the earth a fitting place for both creaturely and divine
> dwelling. In addition to the activity of God (bara), we see
> creatures are also invited to participate in a form of making
> (asah), and this gift sees special focus in humankind made in
> our image (Genesis 1:26–27). Genesis 2:19–20 gives readers
> one of the first immediate echoes of this divine creativity in

Adam's naming of the animals, and not only does the action
recall divinely given power and creativity, but it also echoes
a "putting into place" that is part of that original creative
action. In the act of naming, humans identify and reinforce
their own relationship to the rest of God's creatures, while
granting them a place in relation to one another—Adam
"finds" them, as Ben Quash is apt to express, the animals
becoming intimately known in relation to both humans and
other creatures.[6]

Adam's naming of the animals is not only the first poetic act; it also
is connected to Craft's "placemaking" as the key feature of our steward-
ship of the earth. Ben Quash, a significant voice now in the world of the
arts and faith, draws connections between "finding" and "naming." He
also makes the point that finding is done in freedom. The purposeful and
playful educational plan that God had in mind was that by naming, we
would find, and by finding, we would know our lack.

God's "discovery zone" for human thriving is an environment in
which we can exercise creativity and discover our needs. God intends to
affirm what we create there, to give us dominion over our own creation.
And it was also to know, for the first time, that Adam needed Eve. If
we want to teach our children well and mentor others in the church, we
need to give them dominion, too, over their creative journeys of faith. We
need to give them opportunities to create, and then allow those creative
expressions to stand.

In a New York City subway, I once saw an ad for the Bronx Zoo not-
ing that the zoo has more than four thousand animals. Well, each of those
species has a name, so in Eden, God said "yes" (probably enthusiastically)
at least four thousand times. He also made it clear that Adam "must not
eat from the tree of the knowledge of good and evil, for when you eat of
it you will surely die" (Genesis 2:17). So that's four thousand yeses and

one big "NO." A creative environment must have many "yeses." It also needs clear, consistent boundaries.

When my children were about to become teens, I decided to count how many times in a week I said "no" to them rather than communicating, in some way, an affirmation of their ability to make good choices. I was dismayed to find that I communicated "no" more than 90 percent of the time. Of course, in the fallen universe, parenting soon-to-be-teens does require that word. But I decided that I would work toward four thousand yeses and one big no by replacing my "no" with a modified "yes" at least 50 percent of the time. The only problem was that they found out what I was trying to do, as pre-teens always do, and decided to test my resolve, the result of which was that I came off even worse. But I persisted, trying to trust them more and more and communicate that to them.

In a world of sanctified imagination, we will come to see dominion over the earth as based not on power and domination, but on loving stewardship. Such "finding" of our place is akin to what Wendell Berry has been noted to have said, that when he approaches a land, he does not ask, "What can I take from the land?," but instead asks the land, "What do you need?" Our needs, and our lack, are linked with the land. By naming the animals, birds, plants, insects, and zillions of microbes under the earth, we find ourselves in them, and that deeper poetic knowledge allows us to love fully. The "Eve" we find in that process may be created out of us, but in the sense of dispersed Creation after the Fall, we are not able to fully love until we begin to lovingly name the world around us.

8

The Journey to the New
Through Christ's Tears

For the past decade during the season of Lent, I have meditated on chapters 11–12 of John's Gospel. These chapters continue to hold me, grip me, and haunt me; every time I read them, I make fresh discoveries. Like a deep, murky tidal wave full of creatures, the lives of the siblings at Bethany—Martha, Mary, and Lazarus—invite me to dive deeper and deeper into this story of grief, death, lament, and resurrection.

In 2009, Crossway Books commissioned me to illuminate the pages of a volume titled *The Four Holy Gospels,* an edition of the English Standard Version of the Bible being published to mark the four-hundredth anniversary of the King James Bible. This commission involved more than 250 distinct works of art; I ended up completing 5 large frontispiece paintings, 89 illuminated letters to appear at the beginning of each of the chapters of the Gospels, and 148 pages of illuminations. I was so intimidated by the challenge of this project that I chose the shortest verse in the Bible as my main aesthetic theme: John 11:35, "Jesus wept."

A pinhole camera is created by poking a pin into a box—the smaller and tighter the hole, the clearer the image that will be projected beyond

it. In the pinhole lens of John 11:35, I see the entire narrative of the Genesis Creation story collapse into small droplets flowing down the Savior's cheeks. God created in love, but by that same love, Christ wept.

"Jesus wept" gives us a perspective on God's gratuitous compassion, and it highlights intuition and creativity as entry points into God's Word. A pinhole in a cardboard box will optically capture an image upside down at the back of the box. As I've experienced life's challenges as an artist and as a broken vessel, and as I've been through difficult traumas and the deaths of many loved ones, more and more I am drawn to see all of scripture through this lens. We are used to hearing the Christian gospel as a victorious message, but when viewed through the pinhole of Christ's tears, that gospel may appear a bit "upside down." We are told that by following Christ, everything will be restored; in some cases, we are promised prosperity. Church programs seem to be dedicated to helping us improve our lives, have better marriages, and become better parents. All of these good outcomes are not against God's design for abundance in the world, but John 11:35 adds to the complexity of this version of the Good News.

I began to journey into this mystery of Jesus's tears as I painted in recent times, especially going through the trauma of September 11, 2001. Our family witnessed that devastation, and our children would grow up as "Ground Zero" children; the vacant hole that smoldered for many months after that fateful day was their backyard. I began to feel Christ's tears in me as I walked the streets that I called home. I focused on Christ's tears for me and for the world as I painted. By faith, I began to imagine painting with Christ's tears—began to see that the very materials I use, extravagant, water-based materials, are mixed with Christ's tears.

This creative process illuminates how Christian faith is not a dogma to assent to but an experiential reality that marks our personal journey with Christ's journey of suffering and resurrection as a historical reality. The Spirit's "wordless groans" speak of the entire Creation "groaning as

in the pains of childbirth," awaiting the revealing of us, the children of God (Romans 8:26, 8:22).

In the West, we may not see such groaning as beautiful. But the Japanese concept of *wabi-sabi* sees beauty as rooted in what is passing, and even what is broken, as in Kintsugi. Japanese poets of earlier times speak of enduring beauty that flows out of that groaning of the old. Through the Eucharist, through Christ's body broken for us and his blood shed for us, we enter into that resurrected reality. To extend the metaphor of Kintsugi, Christ sees in our wounds value, to the extent that our sufferings and wounds are invaluable. What we cannot see in our struggles, in our journey into suffering, God sees and the Spirit upholds as precious to who we will become.

In wabi-sabi aesthetic, as influenced by the aesthetics of tea master Sen no Rikyu and his followers, a well-worn, beloved wallet would be valued. Well-loved objects can be intrinsic to our everyday lives and connected intimately to who we are and what we value, as they are part of our daily routine. Thus, in this aesthetic, something that is worn, and lovingly used, is more valuable than something that is new and therefore is connected with Kintsugi.

Wabi is defined as "poverty," and *sabi,* "rust." These implicit values in Japanese aesthetics run so deep in the Japanese psyche that many Japanese would have a hard time articulating them, or even defining them in the way that I am doing here. But this sentiment will appear when Japanese poetry or even pop music speaks of a rusted bridge.[1] Even in *waka* (a short form of poetry) of the eleventh century, the Japanese began to see beauty in sacrifice, in seeing compassion toward a world that is dying or disappearing. *Mono no aware* is a Japanese phrase used to describe the "pathos of things" wearing away. A well-used wallet speaks of the soul of the wallet's owner in ways that a new wallet cannot. Seeing a worn-out wallet as beautiful requires a deeper appreciation of the pathos of, or compassion toward, human touch. So even a wallet is not just a

wallet but carries with it the owner's habits and even love; if an object is well-loved, the object begins to carry the owner's identity, and, it might be said, that object *becomes* part of that person.

Christ bears the nail marks even on his post-resurrection new body. The "carrying over" of the wound of Christ from the old Creation to the New marks a startling portal from which to consider the link between what we do on this side of eternity and what we do on the other side. Our wounds matter to God, as they are connected with Christ's sacrifice. The Japanese of old were right to connect the beauty of a well-loved object (full of the "wounds" of use) or cherry blossoms falling to the beauty of pathos. As followers of Christ, we can connect the wabi-sabi concept to our journey of faith. Stated in such a way to connect the Old and the New, the concept of wabi-sabi may be a Kintsugi bridge between Creation and New Creation. Even such a wallet, therefore, can be part of the journey from Creation to New Creation. How so?

The concept of wabi-sabi and valuing human wear relate directly to the notion of Jesus's tears for us and God's valuing the fullness of our humanity. For Christians, the gold of the Kintsugi is Christ's tears, shed for our brokenness and pain. We see that this pouring of the gold into our fissures of brokenness began at Bethany, with Jesus weeping with Mary.

THE TEARS OF JESUS

In John 11, Lazarus is found sick and dies. Jesus comes to his beside late, intentionally. Before showing his power as the Son of God to resurrect Lazarus, he does something that has no practical purpose: he "wastes" his time with Mary, to weep with her. The thesis of the Theology of Making hinges on this gratuitous act of Jesus, and I develop my thesis

on a kind of culture that flows out of the tears of Christ, rather than on a culture of self-expression or utility. Lazarus's temporary resurrection foreshadows a greater resurrection to come.

John 11 begins with Jesus's mysterious refusal to come in time to Bethany to heal Lazarus, even though his friends and his dear host family and significant supporters Martha and Mary ask him to come. Mary and Martha, sisters of Lazarus, are dismayed and perplexed by this refusal, and even angry at Jesus. "Lord, if you had been here, my brother would not have died" (v. 21), says Martha, as she comes to meet Jesus. Jesus explains: "I am the resurrection and the life. The one who believes me will live, even though they die" (v. 25). Then Martha fetches her sister Mary, saying "The Teacher is here . . . and is asking for you" (v. 28). Mary goes to Jesus and falls at his feet and says, as her sister did, "Lord, if you had been here, my brother would not have died." When Jesus hears these words and sees Mary weeping, he is "deeply moved in spirit and troubled" (v. 33). And he weeps.

Why is this shortest line in the entire Bible, "Jesus wept," the central, pivotal verse for the Theology of Making? What do Jesus's tears have to do with creativity and imagination?

I began this book by exploring the ideas surrounding God's being all-sufficient—that is, God does not need us, or the Creation, but because of God's love we are created extravagantly, excessively, beautifully for the abundant reality. But I recognize that we do not feel like that is the case when we wake up in the morning or face the everyday realities of suffering in our world or immediate struggles of our lives.

When I lived in downtown New York, I woke up every day literally facing Ground Zero in front of me. In those days, I thought often of this shortest biblical passage to help me cope with the trauma all around me. I still do. This shortest passage has become a pinhole in my art and life that has allowed me to see the vast, entire project to be illuminated.

"JESUS WEPT": MARTHA'S RESPONSE

Martha is introduced in Luke 10:38 as a woman who "[opens] her home to him [Jesus]." While she busily prepares to serve Jesus, she sees her sister Mary sitting at his feet, listening to him and not helping her. Luke contrasts the two sisters' responses to Jesus:

> But Martha was distracted by all the preparations that had to be made. She came to him and asked, "Lord, don't you care that my sister has left me to do the work by myself? Tell her to help me!"
>
> "Martha, Martha," the Lord answered, "you are worried and upset about many things, but few things are needed—or indeed only one. Mary has chosen what is better, and it will not be taken away from her." (Luke 10:38–42)

This passage has been used to portray Martha as a sort of busybody and point out the need for people like her to become more contemplative. I call Martha the "CEO of the family" at Bethany. We often remember that Mary is commended for sitting quietly at the feet of Jesus and listening to the voice of her Lord. We say things like "we are busily running around, like Martha, and missing the whole point of serving God." But as we shall see, this interaction is only the beginning of Martha's encounter and her deep, invaluable understanding of Jesus.

It is true that we are far too busy to pay attention to the small miracles happening all about us or to hear the "still small voice" of God (1 Kings 19:12, KJV). So let's spend a little time understanding Mary, Martha's counterpart, to appreciate why Jesus singled her out in commendation. In our techno-frenzied world, we rarely slow down to listen

to each other, and probably even more rarely do we slow down to consider passages of scripture. In the many years I have spent ministering to artists, I have found that people desire to be listened to; they have a deep need for it. The "wasteful" time I spend listening is far more valuable than anything I have said or done for others. We do need to learn to listen, like Mary—to be at the feet of Christ and in the presence of one another as humans made in the image of God, and to be focused on devoting our lives to Christ and to each other. Artists show, intuitively, this capacity to feel deeply the world around them.

George Eliot, the nineteenth-century English novelist, wrote in *Middlemarch*: "If we had a keen vision and feeling of all ordinary human life, it would be like hearing the grass grow and the squirrel's heart beat, and we should die of that roar which lies on the other side of silence."[2] Artists and poets often tap into the intuitive core of experience that "all ordinary human life" has access to. Although Eliot was alienated from the church, her words express the same devotion that Mary showed. It is our responsibility and our calling to "listen" to the mystery of grass growing and to wonder at being touched by "keen vision and feeling." I have never heard a squirrel's heart beat, but Eliot's writing makes me want to. This experience of "the other side of silence" is the timeful potential of art, which is what the Greeks called *kairos,* an "eternal time."

Art also reveals the "roar which lies on the other side of silence." In other words, artists, by being sensitive to the world around them, also feel deeply the wounds and agony of life along with its explosive potential. To know an artist is to know both the depth of sorrows and the heights of joy. Therefore, we need to consider the arts as a way to value life's mysterious details and as a way to train our senses to pay attention to the world. The discipline of the arts allows for this luxurious communing to take place in the deeper soils of all our lives. Artists are the conduits of life, articulating what all of us are surely sensing but may not have the capacity to express.

But having said that, we should not regard the arts as having only utilitarian value. The arts are use-less but a great gift, and therefore indispensable. This is the central thesis of this book: that God, the Artist, "wastes" time with us to listen to our hearts and to be fully present in our suffering. It is not a utilitarian worldview that leads a person to train to become a dancer in order to make that leap onstage at the Joyce Theater in New York City or to practice at the piano keyboard year after year to play a single Chopin sonata at Carnegie Hall. Either of these activities takes enormous sacrifice on a student's part (and the parents' part—so many hours in a minivan!). Often, the complaint against the arts is that art is not directly useful to the creation of wealth and does not serve society in a tangible way. But here, Jesus commends those who consider "what is better," or "the good portion" in some translations. Jesus conveys that Mary's attention is not wasted, as it "will not be taken away from her." I am intentionally linking this "good portion"—the extra, gratuitous reality of Mary listening to Jesus—to art.

What we do to listen to God will not be "taken away," because it is upon such observations and attention that God desires to build the world to come. Mary's response to Jesus, as we shall see, reveals how valuable and central this intuitive capacity is to the Creator. But we will also see that Mary's intuitive response requires her sister, Martha, to respond pragmatically in order to host Jesus. In other words, Mary cannot be herself without Martha.

Thus, it is wrong to simply pigeonhole Martha as an overly busy do-gooder, as that misses Jesus's message. I see her as an active, in-charge person who desires to do the right thing but learns in the gospel narrative how to use her rational and analytical skills for Christ's bidding. As a prime example of how rationality can lead to faith, in John 11, Martha is the first to recognize Jesus and to acknowledge his claims as true.

"Lord," Martha said to Jesus, "if you had been here, my brother would not have died. But I know that even now God will give you whatever you ask."

Jesus said to her, "Your brother will rise again."

Martha answered, "I know he will rise again in the resurrection at the last day."

Jesus said to her, "I am the resurrection and the life. The one who believes in me will live, even though they die; and whoever lives by believing in me will never die. Do you believe this?"

"Yes, Lord," she replied, "I believe that you are the Messiah, the Son of God, who is to come into the world." (John 11:21–27)

Even before the twelve disciples, Martha makes this confession of Jesus as "the resurrection and the life." She sees analytically what no others could discern at the time. She is the first to say "yes" to Jesus's words "I am the resurrection and the life." After Jesus corrects Martha, she allows her sister Mary to continue to listen to Jesus, while she probably continues to work behind the scenes to make her home hospitable. Martha is the host, and yet she becomes the first host to welcome and believe Jesus's promise of the resurrection. So Martha learns and grows in Jesus to understand her role as the "CEO" of the family. Martha is a faithful follower who simply chooses to believe Jesus's word as truth. Even before she sees evidence, she is able to discern God's voice, and accepts it. She is also a doer of the word. It is clear in John 11 that Martha's initial irritation that Mary is not helping her is replaced with a desire to act on behalf of Mary. Martha knows Mary is central in Jesus's journey toward Jerusalem. She is starting to trust Mary's intuition as well.

So Martha acts. She knows what she needs to do after seeing Jesus.

After this confession of Christ as the "resurrection and the life," Martha goes straight to Mary, who is grieving. According to this account, Mary is a bit upset with Jesus. He was delayed in coming to Lazarus. So instead of rushing to Jesus, as the active Martha does, Mary stays behind until she is called by her sister—"The Teacher is here . . . and is asking for you" (John 11:28)—at which time "she got up quickly and went to him" (11:29).

Often, Jesus does call us out of our despair. Jesus doesn't want us to be stoic but rather to be honest about our pain. Both of the sisters believed that Jesus could heal Lazarus and are disappointed that he did not arrive in time to do so.

It is clear that it is Martha who invites the others to the main stage. If Martha represents the analytical and rational, Mary represents the intuitive and creative. Not much is written about the personality of Lazarus, but he could be seen as the third "recipient," a reservoir to receive the grace of both the analytical and the intuitive.

The analytical and the intuitive, the rational and the emotional, the active and the contemplative: these are not dichotomies or dualities opposed to each other, but they are complements. I believe that the rational flows out of the intuitive; the active should be led by the contemplative. But it is also clear from these passages that the rational and the analytical must partner with the contemplative for the full reality of God to break into our world. Martha (the rational and analytical) invites Mary (the intuitive and contemplative) to go see Jesus.

It is interesting, and quite significant, that Martha and Mary make the exact same statement, word for word: "Lord, if you had been here, my brother would not have died." But Martha adds something: "But I know that even now God will give you whatever you ask" (v. 22). I suspect this is Martha's analytical side subtly communicating to Jesus that she needs an explanation. I imagine, on the other hand, Mary's statement was full of emotion, and even anger. These two sisters think so much alike that they make exactly the same statement to Jesus, but Jesus's responses to

them could not be more different. To Martha, Jesus explains the "logic" of the resurrection; to Mary, Jesus does not say a word.

Upon seeing his friends grieving, he weeps.

Why? If he has the power to resurrect, why does he not wave a "magic wand" and solve the problem right away? Why does he "waste time" and weep? This is the pinhole that projects the whole narrative of the gospel, the entire reality of God's Creation and the New Creation. This is the pinhole that projects who Jesus is and what he came to do: to project his own suffering for our sakes.

Suppose God came to me and told me, "Mako, I am going to give you the power to turn back time and stop 9/11 from becoming a reality. Use my power to stop that tragedy from happening." Would I not use the power right away? Of course I would! Jesus possessed such a power, to literally resurrect a dead friend. Why did he not take Mary by the hand, go to the grave, and exercise his power to "solve the problem"?

Earlier in John's Gospel we read that Jesus was also "deeply moved in spirit and troubled" (11:33). The death of his friend Lazarus could have infuriated him. Was he infuriated by people not understanding him? No, Jesus was troubled by, and infuriated by, death itself. At the tomb, again Jesus was "once more deeply moved" (11:38). He took a deep breath and commanded Lazarus to "come out." And he did.

We must pause here and again recognize that Jesus's tears were not necessary. The purpose of his delay was to show his power in resurrecting Lazarus. So why did Jesus "waste time" with Mary, weeping? Why did the Word of God stand silent in Bethany?[3]

Archaeologists have discovered that in biblical times, there were objects that we now call "tear jars." Tears were so coveted that people kept them in jars. Jesus's tears were not collected. They dropped one by one onto the hardened ground of Bethany. They evaporated into the air, and they are still with us today. We can collect them by faith today. Our institutions, and our lives, should be made up of these jars of tears. Our

theology should carry the gratuitous, extravagant weight of those tears. This is the miracle of the intuitive: to invoke mystery that no analysis can tap into.

Jesus's tears were shed onto the hardened ground of Bethany, evaporated, and are still with us. We breathe in his tears every day. I'd like to imagine that these tears, because they are the tears of the Son of God, multiplied, just like the fishes and the loaves, and embedded themselves into the fabric of the atmosphere. Our tears need to commingle with Jesus's tears. It is right for us to be troubled deeply with the broken realities of the world around us. We need to stand in the pit of Ground Zero and breathe in Jesus's tears. Then we can create. Do not let anger overtake you in despair. Let your tears lead to your small resurrections.

The "wastefulness" of Jesus's tears leads to an understanding of God that moves beyond utility and function. From school shootings to tsunamis to the COVID-19 pandemic, the tragedies of our times call us to immediate action, but what God also requires of us is to lament deeply for the losses. Many times in my life, well-meaning people have tried to spiritualize a deep loss or tried to persuade me that God is teaching me lessons through loss and suffering. I've watched pastors and missionaries do the same to others, and I've read books whose authors remind us that our own sufferings are only mirrors of God's sacrifice through his Son on the cross. "Think of how God felt with the death of his only Son," they implore us. Speaking to many who are suffering, I can tell you personally that this kind of advice falls short of the reality of suffering. Christ's tears, and Mary's response to the tears, reveal another path toward our own responses to journey with suffering, a path that reveals a surprising vista toward the New.

"JESUS WEPT": MARY'S RESPONSE

What was Mary's response to Jesus's tears? Through the veil of her own tears, I suspect, she saw in the tears flowing down her Savior's face something of a foreshadowing of his great sacrifice to come. After witnessing her brother rise from the grave, and helping to remove strips of linen and unwrap him, she ran home. Perhaps Mary did not even help with the linen, though Martha certainly would have, but she connected her own brother's rising with her master's death to come. In John 12, Mary is seen anointing Jesus with nard, an expensive perfume. Since there is an account of this event in all four of the Gospels, highlighting the shock and power of this encounter, I revisit the story as it is told in Mark 14.

Mark records that "a woman," whom John identifies as Mary, poured a jar of nard—worth a year's wages—upon Jesus. And she did not say a word. Imagine a bottle of perfume costing your whole annual income! In the Gospel of John, we can surmise that Mary had seen her brother, Lazarus, raised from the grave by Christ. She did "what she could" and responded with a direct, intuitive—but also intentional—act of devotion.

Hauntingly, this act of extravagance provoked an ugly, equally opposite emotional reaction by another disciple, Judas. Mary's act exposed the lie within, a false devotion within Judas.

This Gospel passage seems to point to both the action and the reaction as equally significant, revealing the duality of our own hearts. In John's Gospel, Judas, after vehemently objecting with the other disciples, said, "Why wasn't this perfume sold and the money given to the poor?" (John 12:5). Then he betrayed his master. Mary's act was the straw that broke the camel's back. And Judas betrayed the master for thirty pieces of silver—notably less than the worth of Mary's perfume.

"Leave her alone," Christ says, commending her in front of the indignant disciples. "Why are you bothering her? She has done a beautiful thing to me. . . . Truly I tell you, wherever the gospel is preached throughout the world, what she has done will also be told, in memory of her" (Mark 14:6, 9).

The only earthly possession Christ wore on the cross was the very aroma of the perfume Mary poured upon him. The Roman soldiers who crucified Jesus all could smell her perfume. The Theology of Making is full of this aroma of Mary.

Christ called her act of devotion "beautiful," echoing the Hebrew word *kalos,* a word that appears in the original language of Genesis that tells us that God called Creation "good." What Mary did was good and beautiful. What the disciples deemed a waste, Jesus called the most necessary.

A friend of mine is an architect. People often tell him reasons that they think a church should not spend too much money on designing a church building. Our Christian culture seems to shrink from things that seem extravagant. "What a waste," we might hear, "because we could have fed the poor." My friend notes that when Princess Diana was tragically killed, thousands, perhaps millions, of roses filled the streets of London. No one charged that this was inappropriate extravagance; it was simply a proper way for British people to express their grief. The justification of extravagance, therefore, does not hinge on the amount of money or the number of roses: it has everything to do with the object of our extravagance, the object of our adoration, or the object of our grief.

The problem is not that we do not have an extravagant visual culture; the problem is that we do not believe in an extravagant God. To the degree that we, like Mary, experience the extravagant grace of God, to that degree we will respond extravagantly back to God.

THE GREAT COMMENDATION

"Leave her alone," said Jesus. "Why are you bothering her? She has done a beautiful thing to me. The poor you will always have with you, and you can help them any time you want. But you will not always have me. She did what she could. She poured perfume on my body beforehand to prepare for my burial." (Mark 14:6–9)

I consider my art to be a devotional act, a memorial in response to this woman's act. I use precious materials such as azurite, malachite, and gold. I have done many paintings and installations based on this passage. Working on such an installation, I had an opportunity to share this passage with a gallery owner in New York City who is a feminist art scholar. She noted, "Mary was not supposed to come into that room!" She is right.

Jesus singled out Mary's act as one of the most important things anyone had done for him. "Truly I tell you," he said to the disciples, "wherever the gospel is preached throughout the world, what she has done will also be told, in memory of her."

This was an outrageous encounter that the disciples never forgot. Their shock is both explicit and implicit in this passage. Why were they all so indignant? Explicitly, there were two reasons: they saw the woman's act as inappropriate in the company of men (especially in the home of Simon, a Pharisee), and they also were offended by the intimacy of the moment. There was an implicit message when a woman brought an alabaster jar and gave it to a man. Breaking open the seal would be a highly sexual act (look at Song of Solomon 4). The woman was symbolically giving herself as a bride to Jesus. Such costly perfume was to be saved for her wedding day, to be used only for her bridegroom. Shockingly, she brought it instead to Jesus.

A greater shock was the fact that Jesus received her and commended her. This was not only an unconventional act; this was a transgressive one to their minds. So we can note in Jesus's answer that he was addressing the disciples' fears. Actually, Jesus went further than that by giving them something more to ponder: "She did what she could. She poured perfume on my body beforehand to prepare for my burial." Burial? What burial? The disciples were still blind to the fact that a dark hour was approaching, that Jesus would be betrayed. (Remember that Judas is still in the room.) They still believed that Jesus would triumph over the evils of the present powers.

Jesus, in a coded way, reminded his disciples of what he had been telling them over and over; he is telling them that they don't understand how right she is. He is telling them that he is her bridegroom not in the sense of the old order of things, but in a new, extraordinary way, and that he also is her anointed King. He will be the Bridegroom only after the cross, only after he rises again and only after his triumphal return as that King. He is telling them that she will be remembered as one who anointed him to usher in the Kingdom.

Their heads must have been swimming in confusion as they tried to fathom it. Their thoughts probably went like this:

This woman whom we did not invite came into the room
and held that nard. I heard that this "genuine nard" is passed
down from David's reign and used only to anoint a king.
Mary has a rich father with connections—he probably got
this for her wedding. But she still should not be allowed to
enter this inner circle. And the way she barged in, as we were
trying to prepare our battle into Jerusalem, is ridiculous. Jesus,
how can you receive this woman and act as if she understands
you better than we do? We have sacrificed so much for you!

We could call this the beginning of the feminist movement. Jesus is the founder of every movement that liberates men and women from oppression or inequality. Further, this act of remembrance reveals something about God's way of leaving a legacy.

That evening at Bethany amid the aroma that Mary spilled, one can imagine that Leonardo da Vinci's paintings and Johann Sebastian Bach's cantatas were floating in the air as well.[4] Every act of creativity is an intuitive response to offer back to God what has been given to us. We twist this intuition and may create something transgressive and injurious, but the source of this creative impulse is the Creator.

Again, Mary's nard on his body was the only earthly possession Jesus took with him to the cross.

To me, all art resonates from the aroma of Christ as he hung on the cross. Art seeps out like Mary's nard onto a floor that is supposed to be "clean"; such art reveals what is truly beautiful (Mary's act) and what is truly injurious (Judas's act) at the same time.

I tell many artists about what Jesus states here: "the poor you will always have with you." The central issue here is not, Jesus seems to suggest, the problem separating the rich and the poor. No, the central issue can be posed as a question: Who do we love? Most free and spontaneous adoration transcends time and space. Love breaks open categories, ideologies, cultures, and political divides. So if you are an artist, this passage asks: "Are you passionate enough? Do you have the singular focus that Mary had? Do you create for an audience of One?"

But of course, Mary would have cared very little about these discussions of our motives. She simply took a great risk, trembling in thanksgiving, knowing that the King must be anointed. In one act, she broke open the mystery of the moment. Her nard spread, and its aroma filled the room. It was an ephemeral act, one that she did not think of as "art." I am sure she herself was surprised by Jesus's words that her act would be remembered, that she would leave a lasting legacy. Christ is the great

Artist. Maybe what he saw in Mary was a little-'a' artist emulating and mirroring his great sacrifice.

In Mary's devotion, she expressed the beautiful to Jesus. What makes us truly beautiful? What makes us not just good, not just right, but beautiful? Can our churches be beautiful again, and not just promote goodness and truth? These passages can teach us much about church and life in general, even if you can't see yourself as an artist. It's one thing to aspire to make our work, our businesses, our arts, and our political endeavors good and even "successful." It's another to aspire to make them beautiful. It's one thing to try to educate and raise our children to be good and "successful," but it's another to try to raise them to be beautiful—not superficially beautiful on the outside, but truly beautiful on the inside. What makes this country "America the beautiful"? Is it the beauty of its natural scenery, as we look out from the top of Pike's Peak? Or is it the beauty of the sacrifice seen in the bravery of the firefighters who climbed up those falling towers on 9/11?

Remember, what the disciples deemed a waste, Jesus called the most necessary. We have much to learn from Mary. What is our frivolous act of devotion today? What is our "art"? Mary's act of extravagance is what it means to create in, and through, love. Art, in many ways, helps us in this process of lament. But, again, we must be very careful not to recommend anything to someone who is suffering, as if we know what to prescribe to heal despair. Do not apply plumbing theology to a broken life. Instead, learn to think deeply and experience sorrow deeply yourself, through the arts.

9

Christ's Tears in
the Cultural River

"Jesus wept"—and he continues to weep today. Tears of God are powerful. They may evaporate, or soak the ground, but they never disappear. We breathe today the tears of Jesus. Artists may be the first to recognize the invisible presence of divine tears. That's why the church needs artists—people like Mary—in the world. When we weep and join God, our tears are commingled with God's tears, and multiplied like the fishes and the loaves that Jesus touched.

All of the twentieth century was an upheaval of lament, of angst, of anger: Auschwitz, Hiroshima, Calcutta, Maycomb, Darfur—what the Irish poet Micheal O'Siadhail has called the "irreversible tragedies of our time." We have heard the voices of artists in response, such as Mark Rothko, Pablo Picasso, Max Beckmann, F. Scott Fitzgerald, Ernest Hemingway, Yasunari Kawabata. These expressions may look to some as if they are against God, but they are really not. They might not be "pure" expressions of adoration, but they share in the same tears of the prophets of our day—such as Mother Teresa and Martin Luther King, Jr. The cultural river runs with the tears of God.

Two artists whose work has affected me deeply and helped me to understand the current state of culture are Mark Rothko and T. S. Eliot. They can be our guide to understanding how the biblical text of John 11–12 speaks to our day.

MARK ROTHKO: SOMBER CREATIVITY

Mark Rothko was a twentieth-century master—a New Yorker of Russian Jewish descent, and one of my greatest influences.[1] He resisted descriptions of his work as "abstract," so let's call it nonrepresentational; fields of colors float in the surface of his canvases. Some of my friends have told me that they do not understand his paintings at all. I tell them to sit in front of the work until they do!

I have sat in front of Rothko for a very long time. The National Gallery and the Phillips Collection in Washington, D.C., and the Rothko Chapel in Houston are three places that you might find me doing this. It takes about fifteen minutes before we can feel settled to truly see something. Most of the time, we are trained not to see, but to categorize and move on. It's our basic survival mode. But if you allow yourself to simply sit and stare, the eye can open up to take in beauty in a way that is rarely experienced in life. Rothko painted in layers, and each layer, it seems, comes alive to our eyes after a while.

Why would Rothko paint this way? What was happening in the art world during his lifetime was part of it; photography increasingly took over the role of depicting history and portraiture, and filmmakers were becoming more adept at communicating events and stories. I am convinced, though, that it also had to do with the reality of atomic destruction. After Hiroshima and Nagasaki, an artist had to question fundamentally why we create.

Our creativity created atomic weapons, the most destructive power

to destroy ourselves over and over. What Rothko was after was the profundity of the modern condition, this looking into the abyss and not finding hope.

So when I visit the Rothko Chapel in Houston, a pilgrimage every art lover must make, I stand in front of the image of despair: a black hole of emotion with no end to be seen. The paintings seem to suck out any light, any substance. We are left alone in the room, truly alone.

Why is this experience important? Why should we subject ourselves to the despair of the modern condition through art? Alone in the Rothko Chapel, we begin to cross the threshold into the despair that many people experience after the loss of a loved one. There are no words, no light beyond the abyss, no God.

"Jesus wept."

If we desire to be there with those whose incalculable losses outweigh any sentiments of hope, with those who are too ill to have a future, with those facing the darkness of depression, we need to know how that feels before we can endeavor to be present in suffering. We need to learn to lament and weep deeply for the reality all around us. Rothko helps us to get there.

T. S. ELIOT: THE CLEANSING DARKNESS

After September 11, 2001, I began to journey deeply with T. S. Eliot's *Four Quartets*. Living in Tribeca right next to Ground Zero, I witnessed firsthand with my family the devastation, and later the recovery, of the area where my home was. In the dark days after 9/11, I began to experience physical and psychological dislocation, disorientation, and depression. My studio mate at the time was Hiroshi Senju, and Hiroshi and I spoke of our feeble inability to paint in the same way anymore. I was trapped underground in a subway on 9/11, trying to make it home as the

World Trade Center towers crumbled above me. My train backtracked to Fourteenth Street, right by St. Vincent's Hospital, where doctors and nurses waited for the wounded. When I emerged from the subway, I could not see the Twin Towers because of all the smoke. In those dark days, I carried Eliot's *Four Quartets* in my pocket alongside my Bible. My family was spared that day; the line that divided death and life was so starkly and sharply defined. But 9/11 permanently severed many connections to life and relationships, cruelly and abruptly. On this side of the clear line of life and death that day, I found myself struggling to find stability of my heart.

About two years earlier, the International Arts Movement, an arts organization I founded in 1991, had invited Greg Wolfe to speak on Eliot's *Four Quartets*. I took note at that time of Greg's observation that they are poems of dislocation and synthesis at the same time, a journey between East and West, the present and the past. Soon after 9/11, still displaced from our loft, I contacted Greg. I asked him to guide me through this poetry, and he was kind enough to suggest how I might approach this journey ahead with the poem. Thus the slender edition of *Four Quartets* accompanied me everywhere I went: on the subway to Chelsea, to our temporary home in Brooklyn with our pastor, to my studio in now-sequestered Tribeca. I took it with me when I traveled to Gloucester, Massachusetts, to see Bruce Herman and his wife Meg; and as my sons bounded between the rocks of Cape Ann, I thought of the Dry Salvages.

Apparently, Eliot was in a similar place of uncertainty when he wrote some of the *Quartets*. As an air-raid warden during the Blitz, and sensing the dark shadow overtaking Europe, he needed a guide. For that, Eliot turned to Dante, Saint John of the Cross, Beethoven's late quartets, and many other voices from the past. Greg suggested that if I wanted to truly understand *Four Quartets*, I also needed to delve into Dante, for Dante was one of Eliot's key guides.

So I entered my journey down into the "darker woods . . . where the true way was wholly lost." This journey needed to begin with my footprints fresh on the ashes of Ground Zero. I began to journey with Eliot, who reminds us also that "the way up is the way down."[2] I descended. Now, decades later, I find myself lifted up again in the silver wings of Eliot's words.

Instead of a direct voice of God, a voice heard in such darkness could be the voice of a sojourner who has been before where we are now. Therefore, that voice can guide, instruct, and become our company. After the dark days of 9/11, I experienced, in a small way, this type of death and waiting; and a book of poetry became, at times, my only path to sanity apart from reading the Bible. I began to identify with Eliot, who was a banker as well as a writer. He wrote one of the *Quartets,* "East Coker," as air-raid sirens pierced his ears. Later he remembered the German war planes going overhead. He knew such trauma and darkness, and I heard his voice in the numbing silence of post-9/11 days in New York City.

While my family and I were displaced from our loft apartment near the Twin Towers for two months, my pastor in Brooklyn took care of us. I rode the subway from Brooklyn to Canal Street to get to my studio. Often I felt so disoriented that I did not know which direction I was headed. Then, I would take out *Four Quartets* and begin to read the passages out loud in the subway. I needed God's voice, but I felt the silence of God often in those days. "O dark dark dark. They all go into the dark," Eliot writes in "East Coker."[3] Recently, as I reread these poems, I realized how dark and depressing they truly are. But I found the words to be comforting at the time. They spoke to me of what I felt, what I wrestled with, facing the Ground Zero reality of my backyard.

A second thematic journey I took with *Four Quartets* was as a painter. I did a series of paintings with the titles of *Four Quartets* and exhibited them in Tribeca in my first solo show after 9/11. That led to a second cycle, the collaborative project called Qu4rtets. My paintings and Bruce

Herman's are joined in this exhibition that responds to Eliot; Bruce is deeply moved by Eliot's poetry, too.

One of the first times I heard of Bruce was at a gathering of the organization Christians in the Visual Arts in 1997. I had heard, through a prayer request, that the house and studio of Bruce, a key member of the group, had burned down; he had lost everything he had painted or drawn in the previous twenty years. I remember praying for this man and his family, for his welfare and his heart. But as I prayed, I realized that such a prayer is not to be entered into lightly. What would be my own condition if I were faced with such a destructive fire? Would I be able to move on from destruction of that kind, destruction of my life's work? Or would I be bitter? How should I be praying for this man?

A good friend of mine knows a professor of art who teaches at a major university. He is about the same age as Bruce, and around the same period of his career, he also lost much of the content of his studio in a flood. My friend tells me that to this day, this artist is bitter, and he has not been able to create in the same way since that time. Is that not the most natural thing?—to stay bitter and unable to move on? Our heart's predisposition is to remain trapped in the darker art of despair.

Although 9/11 did not incinerate my works, I felt incinerated on the inside. (I would later lose more than fifty works to Hurricane Sandy, but that is a story for another time.) I realized that the burning Twin Towers, or at least the images of fire, had etched something permanently in my heart. I was trapped in the subway that morning a few blocks from where the towers stood; I did not see anything firsthand. For a visual artist, that was a hidden blessing. Since then, I have tried to avoid media coverage that recounts that day, or the countless movies (it seems) that reenact and document the way the tragedy played out. Fire was no longer merely fire but an explosive fear embedded deep within my psyche.

My grandfather on my mother's side must have experienced something similar, but even more traumatic. He was an educator specializing

in the sciences, and a few weeks after the atomic bomb was dropped on Hiroshima in the summer of 1945, the Japanese government asked him to visit the city and survey the damage. I know his story, told through my mother (and colored by my mother's own trauma: how her father could not speak of the experience for the rest of his life; how he, a lifelong devoted Christian, almost seemed to lose his faith for a long time). How did he move past the trauma, or was Hiroshima so devastating that his faith and hope melted away?

I spoke to Bruce about his fire of destruction the first time we met, in the late 1990s, many years after I uttered that prayer at the conference. He told me, with a grin full of confidence, "That fire was the best thing that happened to me and my art."

What? If this man is not crazy, then how did he get there?

As I journeyed with Bruce in the Qu4rtets project, I came to understand that Eliot had something to do with that confidence. Bruce was going through a sanctification, being "redeemed from fire by fire," as Eliot wrote in "Little Gidding." I had to as well.

In both Rothko and Eliot, then, I am finding a "holy ground" that allows me to journey into my faith, my doubts, and my awareness of suffering. And this connection helps us in our Making journey toward the New. Let me guide us a little farther into the reality of the "fire" that the Bible speaks of—a redemptive reality not because of what is destroyed, but rather because of what is revealed.[4]

A PARADOX OF WATER FLAMES

In 2005, I exhibited a series of new paintings called *Water Flames,* one of which later became the frontispiece for the Gospel of Mark in *The Four Holy Gospels.* Loosely based on Dante's vision of his journey to Paradise via the Inferno and Purgatory, I painted flames with, paradoxi-

cally, water. Hiroshi Senju had given me traditional Japanese vermilion from the estate of the postwar Nihonga master Seison Maeda, and I layered it more than sixty times to create the luminosity. These images are based on a video of memorial flames at Hiroshima. In essence, I combined the flames of Hiroshima with the image from 1 Corinthians 3 of God's flames. So I have been thinking of the symbolic weight of flames in scripture and at Ground Zero.

Flames pop up everywhere in the Bible, from the flaming sword of the cherubim guarding the garden of Eden to the burning bush, from the chariots of fire in 2 Kings to the battle in heaven in the book of Revelation. Fire or flames seem to coincide with the appearance of God, either as a mediating force or bringing judgment. And the weight of flames' symbolism reverberates through all cultures.

What I discovered in the creative process was that when you layer water mixed with minerals onto good Japanese paper, the layers naturally create an image of fire. Paradoxically, earth, air, water, and fire become commingled in a work of art.

Now, think back on my discussion of Mark Rothko.

What I desired to do in the *Water Flames* series was to "fulfill" Rothko's paintings in some way. As a Christian, as someone cognizant of biblical reality that points to a New Earth and New Heaven, I do have an advantage: I create from a vision of the world to come, and not just from the broken realities I experience today. When we identify ourselves with great art, we do not have to stop there existentially; we can begin creating with our hands something that only faith can tell us, but speaking the language of authentic truth that all artists share. Thus, Rothko, a great master, can describe only the edges of the abyss; I, as a Christian, can describe the world beyond them.

Paul writes in 1 Corinthians:

By the grace God has given me, I laid a foundation as a wise builder, and someone else is building on it. But each one should build with care. For no one can lay any foundation other than the one already laid, which is Jesus Christ. If anyone builds on this foundation using gold, silver, costly stones, wood, hay or straw, their work will be shown for what it is, because the Day will bring it to light. It will be revealed with fire, and the fire will test the quality of each person's work. If what has been built survives, the builder will receive a reward. If it is burned up, the builder will suffer loss but yet will be saved—even though only as one escaping through the flames. (3:10–15)

Notice that this passage speaks of fire on "the Day" with a capital 'D.' The Bible speaks of that Day in which Christ will appear as the judge. This fire will destroy anything that is impure, including what is impure in us. Paul is particularly addressing Christ's appearance in the life of a believer. Now, he is speaking in the context of building God's church ("you yourselves are God's temple," 3:16). As a church planter himself, he is addressing the divisions that often occur in a local church. He is exhorting the members of the church in Corinth to come together. He does not want them to come together around destructive, partisan divisions, or to focus on the fire of destruction, but on what will be "revealed with fire," in the death and resurrection of Jesus. He is warning Christians that unless we build on Christ, our contributions to Christ will come to naught—no matter how moral or good our actions seem, no matter how effective we are as activists. Looking at this passage, one can see that apparently this fire of death will make many Christians "suffer loss." Many Christians will be surprised to find that the work they have done for the church, as people of faith, as pastors and teachers, will be tested and found to be not lasting.

The fire that destroyed Bruce Herman's life's work made Bruce even more compassionate, even more creative, and even more dependent on God. He discovered, I think, that it was good to face that judgment now and have his life and his works purified, rather than at the end of his life. The real danger is that we will be surprised at the end of our lives by the real fire of judgment. That is the difference between gold and hay. Gold will be refined by fire; hay will simply burn away. Gold will remain—reshaped, yes, but purified. Hay will simply disappear. If we go through the fire with Christ, and walk with God in faith, we will not be surprised when the Day comes. We already know that fire, so we will recognize it. What we experience will be revealed in Christ.

The Byzantine monk known as Symeon the New Theologian (949–1022) suggests this in his *Discourses:*

God is fire and when He came into the world, and became man, He sent fire on the earth, as He Himself says: this fire turns about searching to find material . . . and for those in whom this fire will ignite, it becomes a great flame, which reaches Heaven. . . . This flame at first purifies us . . . and then it becomes in us food and drink and light and joy, and renders us light ourselves because we participate in His light.[5]

But at the same time, Paul insists in 1 Corinthians 3 on telling us something truly remarkable. Yes, if we do not build on Christ, our works of "righteousness" will come to naught: that is fairly easy to see, if you are a Christian. But the other side of the message, if you are reading the text with a fresh eye, is an incredible, even fabulous promise. The fire of destruction will reveal something you have done, you have built, to be indestructible.

Our works do matter. Our words do matter, and not simply because

they are going to be tested. Our words matter because what we say and do today can last eternally!—even if it is a short word of assurance and encouragement, even if no one sees our act of kindness. That silent submission to forgive rather than stay bitter, that lonely time of walking with Christ alone in the workplace, at school, or in the art world—Christ will use those deeds to build his city of God.

To build the city of God, we need to be a fiery body of Christ. The church is to be a fiery body, like the bush that was burning but not consumed; and we need to be an enigma to the world around us. Holy fire IS burning within us, and we can, with faith, see the presence of Christ in all places, even among the ashes. We can not only see burning bushes, but we can walk in a burning city and live and breathe among the burning people of God. We are burning, yet not consumed. We are people, as C. S. Lewis stated, of "immortal horrors or everlasting splendors."[6]

And I find that these people of "everlasting splendors"—heroes of faith whom I admire, like Dietrich Bonhoeffer or Mother Teresa— seemed to spend a lot of time in the ashes of the world, intentionally going there to experience the burning remains of others.

In the quartet "Little Gidding," Eliot writes, "The only hope, or else despair / Lies in the choice of pyre or pyre— / To be redeemed from fire by fire."[7] What is the "choice of pyre or pyre"? There is really no choice, is there? We are all walking among the ashes and pyres of life, like on 9/11. Our choice seems to be in getting to the desired pyre: the pyre of life underneath the surface or the pyre of death and destruction. The only way to get there is to believe that there is a fire of life greater than the fire of destruction. That fire of death, even as destructive as Hiroshima and Nagasaki, can be met—do you realize?—with a greater and more powerful fire of life. Our works and words can last eternally, if built upon the foundation of Christ.

LEARNING FROM DEATH

Mary's intuition perceived the impending sacrifice of Christ before anyone else could see it. Artists have the ability to peek into the true nature of reality and pose questions that may seem irrelevant at the time. Artists are dealing with a different set of time: time-fullness that is seen in the moment, even if facing a death.

My friend Melissa came to New York City, as a writer, after graduating from a Christian college. Although she was a pastor's daughter, when I met her she was not sure of where she stood spiritually. But via a good mentor and friends, she eventually came to embrace her faith in Christ and to grow in her faith in the spheres of her writing, as an MFA student at The New School and as a wonderful facilitator for the arts. She spearheaded many of our efforts to engage with culture in New York City during the 1990s.

One morning, we had breakfast together. She and her husband were about to move to Nottingham, England, and this was one of the last times for us to get together before her journey. I asked her to pray. And she prayed an unforgettable prayer that echoed 1 Corinthians 3: "Lord, use this food, this breakfast, to prepare us for our deaths."

The words of her simple prayer reverberated in my heart for the rest of the day. Later I emailed her and asked her, "Melissa, what did you mean by your prayer?" She told me that she had just been at her grandmother's deathbed, having taken the responsibility of carrying out her duty, as a granddaughter, to be on a death watch. She watched her grandmother, a woman of faith, be received into Christ's hands late in the evening, and held her hands.

"Lord, use this food to prepare us for our deaths."

Through these simple words, I realized I had in front of me an extraordinarily creative believer, a true follower of Christ. I realized I

was privileged to witness a transformation of someone who ten years earlier had felt uneasy about her faith but now was a vibrant, determined Christian. And she understood that the fire of life and the fire of death are one and the same. She understood that her fire of death sanctifies her.

Do we pray like that?

As Christians, we celebrate the Eucharist. In the bread and wine, the ordinary becomes the extraordinary. In a sense, when we approach the table, we are praying, "Lord, use this food to prepare us for our deaths."

Christ knew, when he instituted this table more than two thousand years ago, what we face today. He has been long-suffering and patient with us, waiting for us. He knew that today, we would be faced with horrific destructive powers and chaotic storms in our lives. He is waiting for us to utter, "Lord, by your death, we live."

Despite the errors and horrors of the day, his death, his fire, will redeem. His body was broken for us so that we can rise to life. His blood was shed for us so that we can receive the wine of joy. That's why Melissa can pray, "Lord, use this food to prepare us for our deaths."

Because by being prepared for death, we live in Christ. This table is a fiery table of Christ: his resurrected presence feeds us with his fire so we will be strengthened to face the fires (and floods) of our lives.

And if you utter these prayers in faith, what you say and do will last, even through the most destructive fires. And Jesus will translate what you say into a building block of eternity. I do not know what that will look like: I only know it will take time. It took Melissa her lifetime to utter those prayers. No, it took faithful grandmothers and several generations of faith for Melissa to utter that prayer.

One thing is sure: As we build on the foundation of Christ, we will choose to be in the pyre. Even our grandmother's deathbed. The pyre is what Christ's building block looks like from the outside. And we will be "redeemed from fire by fire." We will all see and witness that ultimate Fire, both today, all around us, and in that Day.

10

Lazarus Culture

My journey into chapters 11–12 of the Gospel of John has been pivotal for my thoughts on a thriving culture toward the New Creation. I have begun to refer to these thoughts as "Lazarus culture." In these passages of John, not much is written about Lazarus, but he is the reason these stories happened. His illness, his death, and then his resurrection—which, though a temporary resurrection, points to the greater resurrection of Jesus—serve as a framework for Jesus's work and Mary's and Martha's actions.

When I was working on *The Four Holy Gospels* project, these passages of Lazarus haunted me. What did Lazarus hear? He had been dead for a few days. What could he have possibly heard? I tried to imagine this "sound," and paint what I saw.

When we experience darkness, facing the reality of death, there are times we do not hear. We may think God is silent. We wait for God, but we cannot sense God's presence. Perhaps today, even in "wearing a hat of faith," you know that you have reached the end of the road. If you are there, facing the abyss, let me speak to that condition.

Gordon Graham, then of Princeton Theological Seminary, spoke at my church of our Lenten journey. "There is nothing we can do about the resurrection," he told us. Resurrection is all God's work, "but there is much we can do about Good Friday and Holy Saturday." He spoke of Holy Saturday as the most critical; after realizing Christ's work for us on the cross, he said, what we must do is learn to wait. Wait for what? Of course we wait for Easter morning. But there is a sense in which we need to rely on T. S. Eliot's words in his quartet "East Coker" to "wait without hope." Holy Saturday is a day of solemn recognition that we cannot do anything about our own resurrection. We can, by faith, hope for that, but in reality, in our senses, there is no indication of God's work in us. Eliot, as a new convert to Anglicanism, knew about the hope of Easter. His poetic intuition also moved deeply into Holy Saturday, where, as he wrote in "East Coker," "darkness shall be the light, and the stillness the dancing."[1] What he speaks of here is contrition of our whole being that admits that even knowing of a greater hope, we still fail to live in it. We create idols, a kind of escapism, instead of leaning into true hope. We desire to wait for love, but we end up seeking a counterfeit instead.

The art of waiting depends upon our willingness to die to ourselves and trust in God. Art, poetry, and music all depend on waiting. There is no music without pauses. There is no art if we are unwilling to wait for paint to dry. More significantly, the process of making mimics what we need to learn to do in life. Holy Saturday is the critical day on which we are invited to die to ourselves. When we are able to fully die to ourselves, we will hear the voice of God on Easter morning. If we do not, Easter will not mean much.

What Lazarus heard was not the voice of a mere mortal trying to speak of love and hope. What called Lazarus was the voice of a Son of God himself who spoke from beyond the veil into eternity, into the Father's presence. What Lazarus heard was the voice of true hope and true love. What Lazarus heard was nothing short of the voice of Creation.

Before Jesus called Lazarus, he "looked up and said, 'Father, I thank you that you have heard me. I knew that you always hear me'" (John 11:41–42).

The Son of Man had to call upon the Father because Lazarus was no longer living, but with God. Only God could summon Lazarus back toward life, toward his temporary resurrection. What Lazarus heard was the voice of the Son, through the ears of the Father. He heard through God and consequently experienced God's presence fully. The impossibility of hearing God's voice beyond eternity, from death to life, is the beginning of Lazarus culture.

In John 12, Lazarus is seen "reclining at the table with [Jesus]" (v. 2). His resurrection has caused quite a stir, causing Caiaphas to prophesy of Christ's death. There is a warrant out for Lazarus's life (12:10), but Lazarus is reclining at the table with Jesus. Here's what I think was going through his mind, facing these threats by the authorities: "I was dead, and now I am alive; what more can they do to me? As long as I am with Jesus, everything is going to be fine!"

Imagine you were dead in a tomb, and somehow God brought you back to life. That's likely to give you a different perspective on life and death! Lazarus had directly experienced the source and power of life and had heard Christ's voice beyond the grave pointing to the New.

OUR RESURRECTION LIFE

Do you know that we have today, spiritually and historically, more than what Lazarus had then? We live on the other side of the resurrection—not the temporary resurrection of Lazarus, but the permanent resurrection of Christ. We were dead in sin but are now alive, and our attitude should be with Lazarus: "What more can they do to me?" We were "dead in sin," but now we are resurrected with Christ.

Lazarus culture begins by understanding that we can "die in Christ" every moment of our lives but "practice resurrection" (as Wendell Berry puts it in "Manifesto: The Mad Farmer Liberation Front") by being filled with the Holy Spirit, the giver of joy and hope even in the face of the darkest despair. Confidence in Christ is different from "smiling through" tough times: this confidence is a quiet surrender, but an unshakable hope that lies beneath all of our rubble—what poet Christian Wiman called his "bright abyss."[2]

We have nothing to fear in Christ.

I can therefore relax with Lazarus and love freely and boldly, listening to the voice of the Good Shepherd who has called me out of the darkness into the light.

To sum up, three attributes characterized Lazarus's condition. He was *relaxed*—relaxed in the presence of Jesus. He was *confident*—as we can be in the future hope of the Spirit, whatever is happening in our lives. And he was *faithful*—ready to serve God in every moment.

What kind of a culture can we have if we embody the relaxed confidence and faithfulness of Lazarus? How would we react to the present challenges and the chaos in the world from that perspective? In the art world, what does it look like to stay faithful?

Lazarus saw his sister Mary bring the family treasure, fragrant ointment that she was to have saved for her wedding day, and radically, transgressively use it to anoint Jesus. Lazarus saw his sister's face reflect what she went through. If he was perceptive, he also would have seen that the anointing was done in thanksgiving for God's favor. What he did not anticipate, although his sister Mary intuited it, was Jesus's path toward his own suffering at Calvary—Jesus carrying the miracle of Lazarus, and his sins, literally on his shoulders. Mary knew that Jesus would suffer; he would have to pay, somehow, for raising her brother Lazarus, for all that Jesus came to do.

The aroma of Mary's nard filled the air at Bethany. Lazarus,

too, breathed in the aroma. Lazarus culture will be filled with that aroma as well—the aroma of a wedding feast, the cosmic wedding to come.

What does a wedding require of a bride? We are to anticipate that day with all of our resources. We are to think constantly of the Bridegroom. A wedding has, again, all the genres of the arts represented: dance, spoken words, art, culinary expertise, fashion, and music. As wedding planners, we are to create through Christ. We are to present the best; we are to spend the rest of our time preparing. This anticipation will usher in a new age and a new purpose. But it will cost, and it will require sacrifice. We are the children of God in a disfigured, Kintsugi age. Our call is to love in that condition. Our call is to see through the disfigurement and tragedy.

Beauty is not cosmetic. Cosmetic beauty will not result in lasting happiness. We need to love even more through our wrinkled faces. People like Mother Teresa prove that love is the most beautiful gift. In her wrinkles, we see God's love. It is through this path of gaining wrinkles earned by loving people that we will see creativity that not only restores but also redeems. It is with the relaxed confidence of Lazarus that we can truly be present and enjoy the dance, a final dance, that begins the New Creation.

Our world is broken but also enchanted in the sense of the medieval word for gospel, *gōdspel*—"good spell." The words and breath of Jesus have cast a good spell, and Mary's nard, her offering that now has been accepted as part of the New, surrounds us. Now, the arts need to cast good spells into a world that is dying and cynical. If we despair of what we see in the institution of the church, do not "throw out the baby with the bathwater." Jesus, the babe, is the source of life and art that no religious water can tarnish. So it is no surprise that the tales of old that enchanted us when we were children, such as "Beauty and the Beast," seem to fit into our journeys. We can be just as bold as Mary, be relaxed like Lazarus, and prepare well like Martha.

Planning a wedding requires many gifts and skill sets, so this message is not just for artist types. We need wise stewardship of talents and resources, and we need to administer those gifts well. We also need to remember that what really matters in the wedding is not the performers, artists, or even the audience: only the bride and the groom matter. Everything we do at a wedding must give the spotlight to the bride and the bridegroom.

Artists' ambitions and goals should be to participate in that wedding as artists and performers. We need to spend our whole lives preparing for such an opportunity. My ambition is to be invited. Even if I am not chosen to be the head artist of the Cosmic Wedding, I just want to be on the guest list. Maybe I will get to turn Bach's pages as he performs. Maybe I will prepare paint for Michelangelo or hold sculpting tools for him as he carves. What a privilege that would be.

Lazarus culture will imagine and inhabit such dreams. Lazarus culture will paint with Christ's tears. In Lazarus culture we will dance extravagantly, for the bridegroom, Jesus, will have come. Lazarus culture will plan, like Martha, so that our sisters and brothers can give their expensive nard away. Lazarus culture will integrate all aspects of human longing and lead in life-giving gestures.

OUR EMMAUS ROAD JOURNEY

I stood above the hill in Jerusalem overlooking the valley of the Garden of Gethsemane. Over to the left, in Jesus's time there would have been a path toward Emmaus; now there is a road. Later, on a sunny February day, I walked toward that road, aware I was covering ground that Cleopas and the unnamed disciple walked along, as recounted in Luke 24. The cool air caressed me as I walked among the forested hills. What I had come to understand in Galilee—that Jesus invoked the abundance

of Creation in his message of the New Creation—resonated again as I realized that the Emmaus Road literally took the resurrection journey into the forest beyond Jerusalem.

For the disciples of Jesus on their post-resurrection journey, their "Emmaus Road" continued to the banks of the Sea of Galilee and then beyond. Peter would receive a vision that opened the message of the Good News to the gentiles, a dream for which I am grateful. He would take his boat into the ocean to venture to a world he never thought he would reach, leaving from the same port from which Jonah sailed to go to Nineveh. As I stood there at the port of Joppa (or Jaffa) with the singer and songwriter Sandra McCracken, who was touring Israel with me, it occurred to me that a port of exit was the ideal place for two artists to stand: artists often venture out into places unknown, taking the message with them into foreign lands. Simon the Tanner's house, in which Peter saw the dream, is right around the corner; the aroma of the New is all about us.

I imagine Peter's heart racing as he got on the boat. He would have known how dangerous the ocean would be; he was a fisherman who was used to navigating the Sea of Galilee. He knew the ocean was more deadly when it was still. It must have been a challenge to be the "second Jonah," the herald who was to spread the Good News to the gentiles. The first Jonah got swallowed up by a large fish because he was not willing to proclaim God's infinite grace to his enemies in Nineveh. Peter knew his journey promised even further tribulation.

As we follow Christ, we are often called to serve in places we did not want or expect to be. Sometimes our Emmaus Road leads to "songs of descent" rather than the traditional "songs of ascent" that Jewish pilgrims celebrated (recorded in the Psalms) all those centuries ago. Obedience can land us in disorienting situations, centrifugal acts spinning us outward rather than the centripetal experience of being drawn to Jerusalem. The New reverses the spin; instead of being drawn to the Temple, to the

mercy seat, to worship, we are sent out into the world to share the feast with outsiders, migrants, and the poor. Instead of the songs of ascent as we climb toward Jerusalem, we will carry the tears of Christ and sing songs of descent beyond the sea.

Not too far from Jerusalem, beyond the hills of Mount Olive, lie the borderlands of Bethany where Jesus wept with Mary. Gazing toward Bethany I thought of Emily Dickinson, whose poetry attests to the power of dashes and hyphens. Around 1879, she wrote a poem that we call "The Humming-Bird." That title captures the essence of these little miraculous birds. Hummingbirds literally dash in and out of sight, and the dash is the most distinctive descriptor of their movements. Dickinson used dashes liberally and idiosyncratically in her poems, and I thought about the power they exert in them—the pauses they require of the reader in between the words, pauses that do not really make utilitarian sense. Her dashes and hyphens are unnecessary, and the one time she had an opportunity to publish anonymously, her editor removed them for the sake of clarity.

Jesus's tears are like that—perhaps unnecessary for our exegesis of scripture and preaching. But that, to me, is why the gratuitous, even unnecessary tears are the most important element of the gospels.

Lazarus culture will be created from the perspective of the feast, rather than simply in reaction to the fallen conditions that lead artists to create works like Edvard Munch's *The Scream* or Pablo Picasso's *Guernica,* both emblems of the pain-filled realities of the twentieth century. Lazarus culture will integrate the analytical and the intuitive. Those like Martha, gifted in leading an active life of service, can invite the creative and the intuitive, like Mary, to the stage. The cultural soil, like Lazarus, will be receptive and can take the seed of faith and contemplation into a rich, fertile ground.

Finally, Lazarus culture will be Kintsugi culture. His resurrection, though temporary, points to a permanent resurrection. Our wounds will

be healed, but if we take Christ's example, they will still accompany us into the New Creation, although such gold remains of our past will be made more beautiful in the New Creation. God does not just mend, repair, and restore; God renews and generates. God transcends our expectations beyond what we dare to ask or imagine. N. T. Wright writes of the new world of God that it is as "hard to believe as the resurrection itself."[3] Wright here sums up perfectly the entry point for Lazarus culture. Resurrection reality surpasses our own future redemption, but it presents the possibility of our present capacity to create *kainos*, New Newness, for heaven to invade the earth.[4]

Christian community can be, and should be, the most integrated community in the world; the institutions that bear Christ's name should be an oasis of tears; like Martha, Mary, and Lazarus, we each should be, as T. S. Eliot wrote, a "still point of the turning world." Christians can dare to rush into the storms and plagues of life because we have already seen the resurrection, and our intuition to anoint the King has been commended by the King himself. Christians therefore should move with unbridled compassion, gratuitous empathy, and abiding care to collaborate with each other to move into the world, even to the extent of loving our enemies. Christians should have the same impulsiveness and freedom that Mary had. But we have yet to exhibit these qualities and instead may be become fear-filled automatons of utilitarian pragmatism. We can lose our cultural souls if we continue to make bottom-line survival our main concern.

Look to Matthew 16:26: "What good will it be for someone to gain the whole world, yet forfeit their soul? Or what can anyone give in exchange for their soul?"

I return again to Wright's three main pathways toward preparing for "God's new world" to enter ours: the work of compassion and mercy toward justice, the work of creating beauty, and the act of evangelism to proclaim this Good News to all of creation. Mercy and beauty require us

to understand that God is gratuitous with grace; evangelism proclaims that reality. Beauty and mercy were present, and highlighted, in the tears Jesus shed with Mary. And Mary's response to Jesus, as she brought a jar of nard to anoint him, was connected in Jesus's mind to evangelism. As Mark 14:9 says, "Wherever the gospel is preached throughout the world, what she has done will also be told, in memory of her." He does not see us simply as instruments of his purposes for salvation; he sees us as human beings in our full reflection of God. Jesus is not only our Savior, but he stands with us as he did with Mary at Bethany, to weep with us as a true friend. We are not tools to accomplish God's purposes; we are the Bride of Christ. We are to inherit all things, because of Christ's work, and the Spirit's work, in us (Romans 8:17).

Wright continues:

> Every act of love, gratitude, and kindness; every work of
> art or music inspired by the love of God and delight in the
> beauty of his creation; every minute spent teaching a severely
> handicapped child to read or to walk; every act of care and
> nurture, of comfort and support, for one's fellow human
> beings and for that matter one's fellow nonhuman creatures;
> and of course every prayer, all Spirit-led teaching, every deed
> that spreads the gospel, builds up the church, embraces and
> embodies holiness rather than corruption, and makes the
> name of Jesus honored in the world—all of this will find its
> way, through the resurrecting power of God, into the new
> creation that God will one day make. That is the logic of the
> mission of God. God's recreation of his wonderful world,
> which began with the resurrection of Jesus and continues
> mysteriously as God's people live in the risen Christ and in
> the power of his Spirit, means that what we do in Christ and

by the Spirit in the present is not wasted. It will last all the
way into God's new world. In fact it will be enhanced there.[5]

Lazarus culture affirms the "love, gratitude, and kindness" that will
be carried into the new world. Care and beauty that move gratuitously in
love are the materials of the eternal Kingdom to come. What is remark-
able about these thoughts is that the starting point does not come from
us.

Again, God does not need us. God created us, yes, but God is, by
definition, all-sufficient and preexisting, without any needs. God created
us simply out of a gratuitous, greater love. At the point of our rebellion
in the garden, God could have detached from us, rejected us completely.
But God can choose to love again, as a Maker who sees infinite potential
in the Maker's creation.[6] Jesus chose himself to be with the broken, to
suffer for us, and our fissures became filled with gold. What could have
been discarded and detached becomes the most important act of God's
love, and art and beauty that recognize the divides can serve as bridges.
The Holy Spirit enters our hearts as a comforter to bring the seal of
hope. The Holy Spirit reminds us that we are not just survivors of the
cruel game of life but are heirs to this extravagant hope.[7] These are not
paradigms that we can come up with on our own; Jesus's suffering, his
"end," becomes our starting point for the New Creation.

Why is that important? Our understanding of our faith depends on
it! For Christians, the narrative of the Good News, a narrative that begins
in Creation and ends in the New Creation, is not a tool to manipulate
others or a checklist of good behaviors. The Good News is that we are
freed from our perpetual struggle to be gods ourselves. Creating false
gods with every effort, and trying to attain goodness by our willpower,
we constantly try to prove our worthiness and that we are needed. Once
we understand that God does not need us, but despite all of our short-
comings God chooses to love us nevertheless, we are free. We are free

to love; we are free to choose ourselves to spend time, or "waste" time, with those who may be outside of our utilitarian, survival values.[8] We must realize that all that we are, and all that we see, is created in genuine and gratuitous love, and therefore we can love extravagantly and create beauty. Beauty and mercy are extravagant because God simply created an overflowing abundance in the universe and put us in a place of stewardship.

My faith is strong not because I believe in God and God needs my faith; my faith is strong because God created me to have that faith and has chosen me to do God's bidding. I can now hear Jesus's voice through the Spirit and create in the New Creation. My faith is strong because I have absolutely nothing to do with my own resurrection. I neither control my destiny nor have any confidence in myself, but full confidence in the power of God.

DEVOTIONAL: JOHN—IN THE BEGINNING

My painting *John—In the Beginning* was painted live, improvisationally, at Glad Tidings Tabernacle near Ground Zero. Susie Ibarra, an avant-garde jazz percussionist and visionary composer, accompanied me. Painting live with Susie's percussive rhythm helped to capture both the action of the malachite gestures, broad strokes that move across the painting, and the gold flakes that are applied through a bamboo instrument. This work echoes the painting on the book's cover, which is a "Genesis" painting for *The Four Holy Gospels* project.

The first chapter of the Gospel of John echoes the first chapter of Genesis, the beginning of all that we know about God. John expresses the ontology, the source, of what we know to be a beginning. "In the beginning was the Word." The Greek word is *Logos,* and John equates Christ with the *Logos,* the source of all knowledge, wisdom, and art. Of all the

Gospels, John seems closest to jazz. There is much evoked in between words. Even the shortest verse, "Jesus wept," conjures up deep layers of meaning that overlap with our journeys today.

Can one "hear" a painting? Susie tells me that she can when she watches me paint. I see colors in her sound. The redemptive rhythms of John, echoing literally throughout the universe, are full of colors.

A note on the resurrection from 1 Corinthians:

> But if it is preached that Christ has been raised from the
> dead, how can some of you say that there is no resurrection
> of the dead? If there is no resurrection of the dead, then
> not even Christ has been raised. And if Christ has not been
> raised, our preaching is useless and so is your faith. More
> than that, we are then found to be false witnesses about
> God, for we have testified about God that he raised Christ
> from the dead. But he did not raise him if in fact the dead
> are not raised. For if the dead are not raised, then Christ has
> not been raised either. And if Christ has not been raised,
> your faith is futile; you are still in your sins. Then those also
> who have fallen asleep in Christ are lost. If only for this
> life we have hope in Christ, we are of all people most to be
> pitied.

But Christ has indeed been raised from the dead, the firstfruits of those who have fallen asleep. (15:12–20)

Without the breaking in of the miraculous, we will still assume that we are operating in the closed loop of the material universe. This may appear logical on the basis of our modernist assumptions. But human making is much older and more insistent than the closed loop of the thought patterns of the past century. Some consider these "miracle" passages to be primitive and disproved by science. I counter that artists

(and true scientists) know that what we can see, and what we can prove, cannot be the basis of our discovery. Artists discover miracles every day. This is how the miraculous of the New can enter into our world. By "miracles" I do not mean just the supernatural, but all the things, again, that are part of the *poema* (poetry) and *ergon* (hard work) of Making (see Ephesians 2:8–10).

The physical resurrection of Jesus was a miracle beyond all miracles. It was a supernatural intervention, one that had been foretold for many years; yet upon experiencing it and literally beholding the empty grave, eyewitnesses could not wrap their minds around it. Thinkers and writers such as Wendell Berry and Frederick Buechner advise us to "practice resurrection," referring to both artistic or poetic discoveries and physical resurrection. We cannot have one without the other unless we shut the doors of the possibilities of our deeper perceptions completely. Art is fundamentally about the miraculous, so as we make, we are confronted with the impossible. We are, in a sense, "practicing resurrection" by creating art. All makers can follow suit, and every person is, by divine nature, given the possibility of the New.

What convinces me of the physical, bodily resurrection of Christ is not just the making journey, but also the transformation of the disciples and countless other witnesses throughout history. The "unlearned" Galileans who betrayed their leader ran in fear from the authorities, but in time they became a bold, audacious group of leaders and reshaped the world. It is their transformation—or perhaps the better word is "transfiguration" (Greek *metamorphoo*)—that undergirds my journey into faith. There is evidence of that transfiguration both in scripture and in history. Could it be that I, too, weak and fragile as I am, can find strength and courage under fire? Can that audacious gift be part of my art?

PRACTICING RESURRECTION

In the art world, claiming to be a follower of Christ often seems as transgressive as anything that one could do in a world full of transgressions. But when I speak of "practicing resurrection," artists welcome it—even those who are atheists. They see such practice as an act of resistance against the status quo, or the world that wants to negate our creative resistance. I see these resurrection moments everywhere. Let me tell you the story of one of them.

After my book *Silence and Beauty* was published in 2016, I set off on a book tour. The Windrider Productions team followed me from Nagasaki to Tokyo to film me. I collaborated with two TED Fellows and dear friends, Susie Ibarra and Andrew Nemr (who, in a possibly unique vocational combination, is a tap dancer and a pastor). We were shooting a documentary related to *Silence and Beauty* in Shibuya, a section of Tokyo, with one of Andrew's Japanese collaborators, Nao, who is also a tap dancer. Susie had her nine-year-old son, Emanuel, with her, and we were exhausted from shooting in driving rain brought on by an approaching hurricane. We grabbed a cab that happened to be driving along a small alley we were dashing through to get back to the hotel after a long day.

The man at the wheel had been driving taxis for more than forty years. He was one of those "professional" drivers with an extremely refined driving style and hospitable spirit. I sat next to him in the front seat and found the banter delightful. I told him that sitting behind him were two tap dancers (their tap board took up most of the space in the back seat) and a world-class avant-garde percussionist with her son on her lap.

He didn't respond for a while, and I thought perhaps he could not hear me. But then he said, "My wife was a drummer. She passed away last July and I have kept the drums, not knowing what to do with them."

I translated and conveyed this to my companions. Then something

unexpected started. Nao and Emanuel began to tap with their fingers on the tap board simultaneously.[9] Susie joined in. Then Andrew.

What developed over ten minutes was an improvised percussion concert on an oversized tap board in the back seat of a Tokyo taxi, one driven by a grieving, stoic driver.

The driver began to tap his fingers, too, and took a deep breath. It would have been out of character and an affront to his professionalism to go much beyond the normative, acceptable level of conversation with customers. But he let out a single, drawn-out breath, as if to acknowledge that the spontaneous cacophony, a spell of the life-beat, was being done in memory of his wife. "Music is miraculous," he murmured. The sound of the pulsating life-beat continued until the automatic door on the taxi opened at the hotel.

He thanked me profusely as I paid for the ride. He returned my credit card as though he were handling a profound gift, a sacred object. His fingers trembled, and there were tears in his eyes.

Here's what I believe about the New Creation: What happened spontaneously in that taxi cab will remain forever. This, I told a sojourner later, was an example of the New Creation breaking in. There was no sermon, no explanation, just the spontaneous act of honoring the taxi driver and the memory of his wife. This did not "fix" the problem of death or remove the source of mourning. We did not advise him about what to do with those drums.

But the New Creation broke in, gratuitously, and surprised all of us even as we danced with our fingers. New Creation fills in the cracks and fissures of our broken, splintered lives, and a golden light shines through, even if only for a moment, reminding us of the abundance of the world that God created, and that God is yet to create through us.

The Theology of Making journey has only just begun with this final chapter of the book. The journey is not just for artists and theologians. The word "art" may result in thinking that this book is only for artists.

The word "theology" may result in thinking that this book is only for Christians. By connecting "art" to Making, I am intentionally broadening the word "art" to every human being's act of making. We are all artists in that sense. This book also broadens the word "theology," directly connecting "knowing God" to all of our making as well. Certainly, a theologian is someone who intentionally focuses on the study of God, and preaching is one of Christendom's major art forms. But the resurrection into the New is a journey that we are all on, regardless of whether we can cognitively acknowledge that. There are burning bushes everywhere, burning yet not consumed, and our lives can be just as miraculous. Our Making can be a visible marker of God's gratuitous love. Christ's ever-present tears can inspire our lives and our beautiful, sacrificial, and extravagant responses. Christians are to be marked with Making into the New, and we are also here to help make sense of the expressive markers of the Maker working through others, including non-Christians. Thus, the following benediction is for all people made in the image of the Maker, the only true Artist.

Let us reclaim creativity and imagination as essential, central, and necessary parts of our faith journey. Imagination is a gift given to us by the Creator to steward, a gift that no other creature under heaven and earth (as far as I know) has been given.

Our dreams and hopes are part of our faith; and of course, like all good gifts from God, we can twist these good gifts and make them into idols. In modernist circles, art has been seen as a way to replace God; the Theology of Making will necessarily place art as a good gift of the Creator God, the *Semper Creator,* who continues to create into the New Creation. Therefore, art is connected to the holy. Art communities and church community life depend on such roots in the imagination. Such gifts of the New breathe life into all of our communities, and holiness is the result of such imaginative work. I would add that—whether through "sacred" or "secular" efforts—the expression of our imaginative works in social and interpersonal relationships is itself a work of art of God. This

imaginative act, released in a community, is to see ourselves as masterpieces (*poiema*) of God's design. The Bible begins in Creation and ends in New Creation. Everywhere in between is the narrative of the broken people of God somehow being invited back and back again to reestablish this relationship with the Creator, and to be makers of the New, as heirs to the greater reality that this God is all about.

God is an artist. God is THE Artist (the ONLY true Artist), and an Artist creates and makes. God stated "Let there be . . . ," and there was the world full of abundance and poetry. God invites us not to a church program (as important as those may be) but, as N. T. Wright has noted, to a meal. God THE Artist invites little-'a' artists to a feast and a dance. And, I understand now, it took Jesus to give himself to us, to shed tears for our current state, for us to be invited by grace. I end this book with a benediction for all of us on this journey toward the New.

A BENEDICTION FOR MAKERS

Let us remember that we are sons and daughters of God, the only true Artist of the Kingdom of abundance. We are God's heirs, princesses and princes of this infinite land beyond the sea, where heaven will kiss the earth.

May we steward well what the Creator King has given us, and accept God's invitation to sanctify our imagination and creativity, even as we labor hard on this side of eternity.

May our art, what we make, be multiplied into the New Creation. May our poems, music, and dance be acceptable offerings for the cosmic wedding to come. May our sandcastles, created in faith, be turned into permanent grand mansions in which we will celebrate the great banquet of the table.

Let us come and eat and drink at the supper of the Lamb now so that we might be empowered by this meal to go into the world to create and to make, and return to share what we have learned on this journey toward the New.

Notes

CHAPTER 1. THE SACRED ART OF CREATING

1. All scripture quotations, unless otherwise indicated, are taken from the Holy Bible, New International Version, NIV, copyright © 1973, 1978, 1984, 2011 by Biblica, Inc.; used by permission of Zondervan; all rights reserved worldwide, www.zondervan.com. The "NIV" and "New International Version" are trademarks registered in the United States Patent and Trademark Office by Biblica, Inc. Other translations: King James Version (KJV) and English Standard Version (ESV).

2. I explore this more in my book *Culture Care: Reconnecting with Beauty for Our Common Life* (Downers Grove, Ill.: IVP Books, 2017).

3. N. T. Wright, email correspondence with the author.

4. Dorothy Sayers, *The Mind of the Maker* (San Francisco: HarperCollins, 1968), 22.

5. This observation is an inference, as the Israelites were enslaved in Egypt before God liberated them. The crafting methods Bezalel and Oholiab used, working with precious metals and gems and carving wood, were not methods that came out of a vacuum in Jewish craft culture. While it is likely that the two men were known by their peers and in their communities for their gifts, I imagine them learning from the best in Egypt, as Picasso would have done in Paris in the early twentieth century.

6. Amy Whitaker, *Art Thinking: How to Carve Out Creative Space in a World of Schedules, Budgets, and Bosses* (New York: HarperBusiness, 2016), loc. 366, Kindle.

7. Frank Kermode, *The Sense of an Ending: Studies in the Theory of Fiction* (New York: Oxford University Press, 1967).

8. Lisa Sharon Harper, *The Very Good Gospel: How Everything Wrong Can Be Made Right* (New York: Penguin Random House, 2016), 20.

9. *The Four Holy Gospels* (Wheaton, Ill.: Crossway, 2011).

10. See Claude Monet's painting *The Saint-Lazare Station* (1877), which captures the optimism of how industry can forge our future hope.

11. I am grateful to Bill Edgar for introducing me to the concept of "Creator-creature distinctions."

12. I am grateful to Joy Sawyer for pointing me toward researching the word *poiema*. See her book *Dancing to the Heartbeat of Redemption: The Creative Process of Spiritual Growth* (Downers Grove, Ill.: InterVarsity, 2000).

13. Even the Greek word for "shepherd" is *poimen,* indicating that shepherding is an artful act of stewardship.

14. "Then Jesus said to his disciples, 'Whoever wants to be my disciple must deny themselves and take up their cross and follow me'" (Matthew 16:24; see also Mark 8:34 and Luke 9:23).

15. Norman Maclean, *A River Runs Through It* (Chicago: University of Chicago Press, 1976), 4.

16. I am grateful to Love Sechrest for suggesting the duality of the word *poietes* to mean both "doer" and "poet" of the Word.

CHAPTER 2. THE DIVINE NATURE OF CREATIVITY

1. This is the basis of my earlier book *Culture Care: Reconnecting with Beauty for Our Common Life* (Downers Grove, Ill.: IVP Books, 2017), which is a broader, public expression of the Theology of Making applied to the entire culture.

2. Recently, my friend David Brooks referred to his journey as one of "border-stalking," an identity that helped him to orient his journey into faith. David Brooks, *The Second Mountain: The Quest for a Moral Life* (New York: Random House, 2019).

3. See Jacques Ellul, *The Technological Society* (New York: Vintage, 1954).

4. Makoto Fujimura, "Emily Dickinson, Rachel Carson, and the New Creation," October 28, 2018, presented at Baylor University's Stewardship of Creation Conference, 2018 (www.makotofujimura.com/writings/emily-dickinson-rachel-carson-and-the-new-creation).

5. As regards the culture care project, see International Arts Movement (IAM) Culture Care (www.internationalartsmovement.org).

6. Karl Barth, *Ethics,* trans. Geoffrey W. Bromiley (reprint; Eugene, Ore.: Wipf & Stock, 2015), 507.

7. I thank my friend and colleague Bruce Herman for pointing out that in order to "understand," one must be willing to "stand under."

8. Esther Lightcap Meek, *A Little Manual for Knowing* (Eugene, Ore.: Cascade Books, 2014).

9. David Brooks, "Longing for an Internet Cleanse," *New York Times*, March 28, 2019.

CHAPTER 3. BEAUTY, MERCY, AND THE NEW CREATION

1. This approach of two paths is suggested by N. T. Wright, who adds "evangelism" as a third way. N. T. Wright, *Surprised by Hope: Rethinking Heaven, the Resurrection, and the Mission of the Church* (New York: HarperOne, 2008).

2. Lewis Hyde, *The Gift: Creativity and the Artist in the Modern World* (New York: Random House, 2009).

3. See Makoto Fujimura, *Silence and Beauty: Hidden Faith Born of Suffering* (Downers Grove, Ill.: IVP Books, 2017).

4. Wright, *Surprised by Hope*, 208.

5. Richard J. Mouw, *When the Kings Come Marching In: Isaiah and the New Jerusalem* (Grand Rapids: Eerdmans, 2002).

6. Isak Dinesen, "Babette's Feast," in *Anecdotes of Destiny and Ehrengard* (New York: Vintage, 1993), 58.

7. J. R. R. Tolkien, "Leaf by Niggle," in *Tree and Leaf* (London: George Allen & Unwin, 1964). The Trinity Forum publication includes my foreword (archive.ttf.org/product /leaf-niggle).

8. Ellen Davis, *Scripture, Culture, Agriculture: An Agrarian Reading of the Bible* (New York: Cambridge University Press, 2008), 45.

9. This size is just large enough that the paintings will not be easy to transport or exhibit without much planning, so the project is a nonutilitarian effort and not very efficient.

CHAPTER 4. KINTSUGI

1. This thought naturally descends from rejecting the notion that God does not need us or accepting God's self-sufficiency, discussed earlier.

2. One of my fellows, Clover Zhou, has found evidence of Kintsugi practice in tenth-century Chinese art. If this is the case, Kintsugi originated in China and then was practiced in Korea and refined in Japan.

3. Bruce Herman calls border-stalkers *mearcstapas* (see more in Makoto Fujimura, *Culture Care: Reconnecting with Beauty for Our Common Life* [Downers Grove, Ill.: IVP Books, 2017]).

4. For this effort to create a culture care movement, see International Arts Movement (IAM) Culture Care at iamculturecare.com.

5. In many ways, the transgressive art of contemporary times, whether that art is in music, the visual arts, cinema, dance, or theater, speaks to the possibilities of this "New Newness." My colleagues Rob Johnston and Kutter Calloway of Reel Spirituality at the Brehm Center at Fuller Theological Seminary focus on cinema as a means to understand the Spirit's broader work in culture, a work that is often not seen by the church. One of my fellows, Jeremy Hunt, wrote a doctoral thesis called "Hard Metal Rock and Theology." Such unexpected places of theological discoveries are important precisely because the New Newness is hard to recognize in conventional patterns. Enduring art often seems completely unacceptable by society, because the artist sees, or intuits, something of this New. Yet, as I've noted many times, such instincts and receptiveness can easily be distorted, often causing havoc in artists' personal lives, and the gift can easily become a curse. Even in such brokenness, however, the Kintsugi Theology of this project can begin to not only mend the broken vessels of God, but bring something entirely New into the world and beyond.

6. Windrider Productions (partner of Sundance Film Festival) was creating a short film based on my journey of art and has produced a short film on Kintsugi.

7. "Kintsugi Pieces in Harmony," YouTube, April 12, 2017 (www.youtube.com/watch ?v=i8m_AeTGcmk).

8. Raku is the traditional Japanese way of creating ceramics using natural kilns. The Raku Museum is in Tokyo.

9. See Brother Lawrence, *The Practice of the Presence of God* (reprint; Grand Rapids: Baker, 1989).

10. What we found, in running Kintsugi workshops with Master Nakamura, is that it is hard to find broken bowls in the United States, as our consumer mindset does not allow us to think of broken things as being valuable. In this sense, Kintsugi flows out of a mindset of scarcity, of keeping even what is broken, as many from postwar generations have the habit of doing. Yet, it is how the Kintsugi aesthetic moves past the scarcity into what I call the generative that makes Rikyu's aesthetic so enduring.

11. Master Nakamura worked with a fishing rod company to produce his own Japan lacquer, one that does not take a year to dry and is made of a substance that does not cause an allergic reaction in many people (Japan Urushi is made from poison sumac). This new glue makes Kintsugi available to a wider audience.

12. N. T. Wright, *Surprised by Hope: Rethinking Heaven, the Resurrection, and the Mission of the Church* (reprint; New York: HarperCollins, 2009), Kindle edition, 207.

13. My commencement address, "What Do You Want to Make Today?," at Biola University in 2012 (ccca.biola.edu/resources/2012/may/25/what-do-you-want-make-today).

CHAPTER 5. CARING AND LOVING, THE WORK OF MAKING

1. Esther Lightcap Meek, *Loving to Know: Covenant Epistemology* (Eugene, Ore.: Cascade Books, 2011), 33.

2. I often refer to this judgment as a "farmer's market" test. Whether it is a political candidate, choice of meals, or local apples, we should "test the fruit" and make our judgment on the basis of what we can taste and experience. It is true that such an experience can lead to long lines forming, but we should ask "is this line forming because of the actual taste of what is being sold?"

3. My thanks to David Miller for teaching me this word.

4. Lewis Hyde, *The Gift: Creativity and the Artist in the Modern World* (reprint; New York: Vintage, 2007), xvi.

5. Capitalism, in this sense, depends on Hyde's "gift economy" to thrive, as human beings need to be loved beyond mere survival. See Bruno Roche and Jay Jakub, *Completing Capitalism: Heal Business to Heal the World* (Oakland, Calif.: Berrett-Koehler, 2017).

6. Hyde, *The Gift*, 15.

7. Colossians 1:16, "For in him all things were created: things in heaven and on earth, visible and invisible, whether thrones or powers or rulers or authorities; all things have been created through him and for him."

8. Hyde, *The Gift*, loc. 1004, Kindle.

9. I thank my mentor Tim Keller for these theological strands; Timothy Keller, *Prodigal God: Recovering the Heart of the Christian Faith* (reprint; New York: Penguin, 2011).

10. Hyde, *The Gift*, 300.

11. Jacques Maritain, *Creative Intuition in Art and Poetry: The A. W. Mellon Lectures in the Fine Arts* (New York: Meridian, 1953), 85.

12. Along with the influence of Joy Sawyer, I acknowledge the songs and writings of Michael Card in my understanding of the "*poietes* reality" of the scriptures.

13. In the Catholic understanding of transubstantiation, the bread and wine are the actual body and blood of Christ. Although I do not subscribe to this view, I have a wider view of the elements as invoking the resurrected Christ to the table with the worshippers.

14. I thank my friend Andy Crouch for his lectures on "Culture Making," which spurred on this thought.

15. Malcolm Gladwell, *Outliers: The Story of Success* (New York: Little, Brown, 2008).

CHAPTER 6. SEEING THE FUTURE WITH THE EYES OF THE HEART

1. Waterfall Mansion and Gallery (www.waterfall-gallery.com/makoto-fujimura-x-gary-lichtenstein-project).

2. I thank Roberta and Howard Ahmanson for their collecting my *Golden Sea* painting, which inspired the print, as well as hosting me at their Newport Beach home to ponder the "Sea Beyond" journey at my darkest hours.

3. Japanese *Kumohada* paper was created after the war to accommodate very large paintings by Heizaburo Hirano in Imadate, Japan.

4. C. S. Lewis, *Mere Christianity* (reprint; San Francisco: HarperOne, 2015), 183–84.

5. For the "tabernacle of Christ," see Hebrews 9:11, "But when Christ came as high priest of the good things that are now already here, he went through the greater and more perfect tabernacle that is not made with human hands, that is to say, is not a part of this creation."

6. Jürgen Moltmann, *Theology of Hope* (London: SCM, 1969).

7. Oliver Davies, *The Creativity of God: World, Eucharist, Reason* (Cambridge: Cambridge University Press, 2004), 95.

8. Daniel N. Robinson, *Principia Ethica* (New York: Dover, 2004), 84.

9. Robinson, *Principia Ethica*, 84.

10. Moore quoted in Robinson, *Principia Ethica*, 84.

11. I am grateful for a conversation at the Anselm Society in Minnesota for this statement.

12. Jürgen Moltmann, *In the End—the Beginning: The Life of Hope*, trans. Margaret Kohl (Minneapolis: Fortress, 2004), loc. 44, Kindle.

13. Ellen Davis, "The Preacher as Public Imaginer," lecture given at Trinity Church, Princeton, N.J., September 15, 2018.

14. William A. Dyrness, *Visual Faith: Art, Theology, and Worship in Dialogue* (Grand Rapids: Baker Academic, 2001), loc. 1335, Kindle.

CHAPTER 7. IMAGINATION AND FAITH

1. Howard Gardner, *Intelligence Reframed: Multiple Intelligences for the 21st Century* (New York: Basic Books, 1999), 130.

2. William Blake, "Appendix to the Prophetic Books [From Blake's Engraving of the Laocoon]," Bartleby.com (www.bartleby.com/235/341.html).

3. Oliver Davies, *The Creativity of God: World, Eucharist, Reason* (Cambridge: Cambridge University Press, 2004), 57–58.
4. As this book continues I explore the viability of images as one of the bases of knowledge. I call this concept Visual Theology. By that, I do not mean rational theology, or systems of theology illustrated by an artist to serve that system. What I mean by Visual Theology (a critical thesis for the Theology of Making that theologian William Dyrness has promoted) is the possibility that what we see, or even what we do not see yet but will come to know only through the eyes, is the reality of God. This book is a beginning of our journey to realize fully that as the "people of the Word" we are to *see* the Kingdom.
5. William James, "What Pragmatism Means," in *Pragmatism: A Reader,* ed. Louis Menand (New York: Vintage, 1997), 126.
6. Jennifer Allen Craft, *Placemaking and the Arts: Cultivating the Christian Life* (Downers Grove, Ill.: IVP Academic, 2018), 26–27.

CHAPTER 8. THE JOURNEY TO THE NEW THROUGH CHRIST'S TEARS

1. Pop singer Mika Nakashima's profound song "Boku ga Shinouto Omottanowa" (The Reason Why I Thought to End My Life) includes these lines (my translation):

> My dear plum tree blossomed on my birthday
> If I fall asleep beneath it, with the branches bathed with light,
> would I go back to earth becoming just like these bugs?
>
> Mint candy, fisher's lighthouse
> A rusted bridge, a lost bicycle
> A stove warms at a wooden station, I long to set out afar but I cannot.
>
> Today is just like Yesterday; for tomorrow to change, we must start from Today.

2. George Eliot, *Middlemarch* (New York: Penguin Random House, 2015), 67.
3. I thank Richard Hays for this comment at Duke University when I made a presentation on John 11.
4. I thank Jamie Elaine, artist-curator, for this idea.

CHAPTER 9. CHRIST'S TEARS IN THE CULTURAL RIVER

1. My interview about Rothko in *Rothko: Pictures Must Be Miraculous*, directed by Eric Slade, PBS *American Masters*, season 3, episode 12, aired October 25, 2019.
2. T. S. Eliot, "The Dry Salvages," in *Four Quartets* (New York: Mariner, 1968), 35.
3. Eliot, *Four Quartets*, 23. I recommend that you look at Eliot's poetry with me. Imagine with me as you read a portion of "East Coker," as you absorb these words by Eliot. Read them out loud as they should be read, and imagine we are in the subway.
4. See my collaborative project Qu4rtets, at iamculturecare.com/projects/qu4rtets.
5. Discourse 78 quoted in Subdeacon Matthew, "Our God Is a Consuming Fire," Engage Orthodoxy, March 2019 (www.engageorthodoxy.net/the-soul-is-greater-than-the-body-1/2019/4/6/our-god-is-a-consuming-fire-pdjtp).
6. C. S. Lewis, *The Weight of Glory: And Other Addresses* (San Francisco: HarperOne, 2001), 47.
7. Eliot, *Four Quartets*, 57.

CHAPTER 10. LAZARUS CULTURE

1. T. S. Eliot, "East Coker," in *Four Quartets* (New York: Mariner, 1968), 28.
2. Christian Wiman, *My Bright Abyss: Meditation of a Modern Believer* (New York: Farrar, Straus and Giroux, 2013).
3. N. T. Wright, *Surprised by Hope: Rethinking Heaven, the Resurrection, and the Mission of the Church* (New York: HarperOne, 2008), 208.
4. It may be pointed out here that Lazarus, Mary, and Martha represent what the best pursuit of education focused on: goodness, beauty, and truth. Lazarus represents the goodness of the life in Christ, Mary represents the beauty of anointing, and Martha represents the truth of the Gospel. Lazarus culture can lead to a generative educational model, giving attention to all three ways of knowing the world.
5. Wright, *Surprised by Hope*, 208.
6. Or to be more theologically accurate, God is "predestined" in God's love to choose God's self-election to love us eternally (from my notes of a lecture by Jürgen Moltmann at Princeton Theological Seminary in the spring of 2017).
7. Romans 8.
8. About "wasting" time, see Marva Dawn, *A Royal Waste of Time: The Splendor of Worshiping God and Being Church for the World* (Cambridge: Eerdmans, 1999).
9. Susie told me later that it was Emanuel who began this—thus a child shall lead the way into the New.

Index